D1093193

/o ARCHIE

WITH MY LOVE

1/7/16

From Benty. xx

# WILD ISLAND

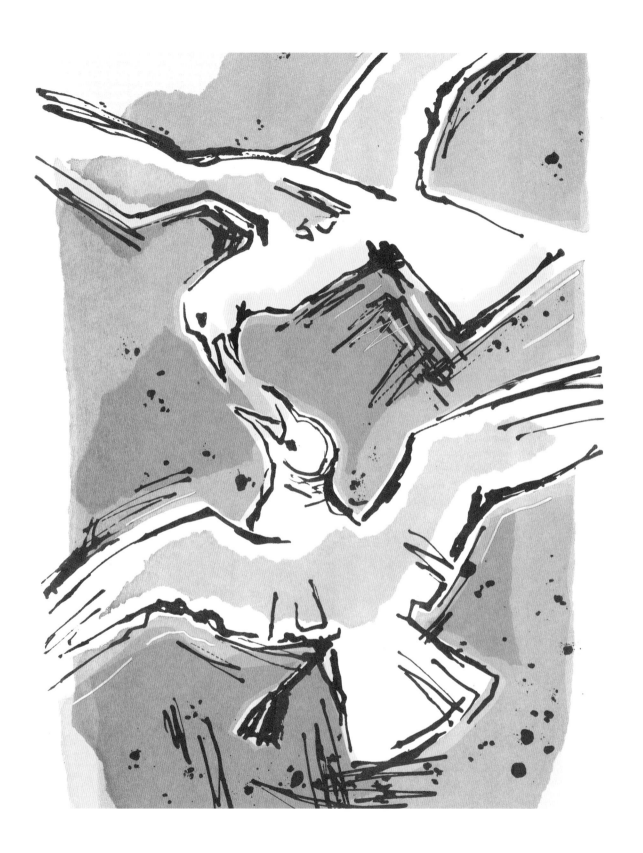

# WILD ISLAND
## *A Year in the Hebrides*

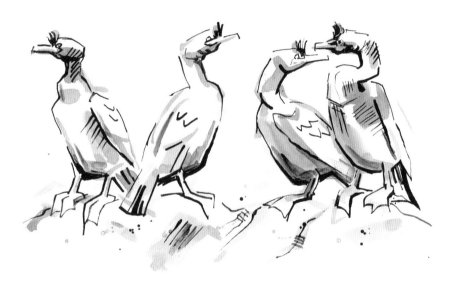

## JANE SMITH

EDINBURGH

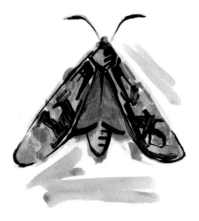

First published in 2016 by Birlinn Ltd
West Newington House
10 Newington Road
Edinburgh
EH9 1QS
www.birlinn.co.uk

Illustrations and text © Jane Smith, 2016

Design and layout by James Hutcheson and Tom Johnstone

The right of Jane Smith to be identified as the author of this work has been
asserted by her in accordance with the Copyright, Design and Patent Act 1988.

All rights reserved. No part of this publication may be reproduced, stored, or
transmitted in any form, or by any means, electronic, photocopying, recording
or otherwise, without the express written permission of the publishers.

ISBN: 978-1-78027-269-6

British Library Cataloguing in Publication Data

A catalogue record for this book is available from the British Library

Typeset in Arno Pro at Birlinn

Printed in Latvia by Livonia

# FOREWORD

This book unveils the wonderful world of the Hebridean island of Oronsay and lets you visit one of the most challenging and rewarding workplaces that the RSPB manages as a nature reserve. Successful conservation management is far more difficult and significantly harder work than most of us can imagine. It involves an intimate understanding of many natural processes and the detailed life history of the species you wish to benefit. It needs a knowledge of land, and of how it has come to exist in the state we now see it.

If that isn't difficult enough, transfer your endeavours to a tiny and remote Hebridean island where the habitat management is achieved via cattle, sheep, arable crops, machinery and a constant flow of enthusiastic and characterful volunteers.

Through her beautiful illustrations, Jane captures the mood and atmosphere of this magical island, its very special wildlife and the people who live and work there. If you read this in winter, think of the 6.00 am start and the round of feeding and checking the out-wintered livestock, and maybe put another log on your fire and imagine the raging gale and rain coming straight off the Atlantic. If you read this in late spring, imagine the air filled with birdsong, tumbling lapwing, the heartlifting song of skylarks and the rasping calls of corncrakes hidden in the vegetation managed specifically for them; perhaps, like me, you will be envious of those who can still experience this natural symphony.

Jane's illustrations and prose transport you to a very special place and let you into the lives of some very special people. They describe part of the 15 years that Mike and Val Peacock have spent on Oronsay, skilfully managing this nature reserve and meeting all of the challenges thrown at them. People like Mike and Val quietly get on with this kind of work because it really matters to them, and reading this book will help you appreciate their work and perhaps it will also encourage you to join in and do something, however small, to contribute to and make space for the wildlife we enjoy and share our planet with. At the annual Nature of Scotland Awards in 2015 Mike and Val were both awarded with the 2015 Lifetime Achievement Award, and Mike the Species Champion Award. But their achievements cannot be described more eloquently than in the pages of this book.

Stuart Housden, Director, RSPB Scotland

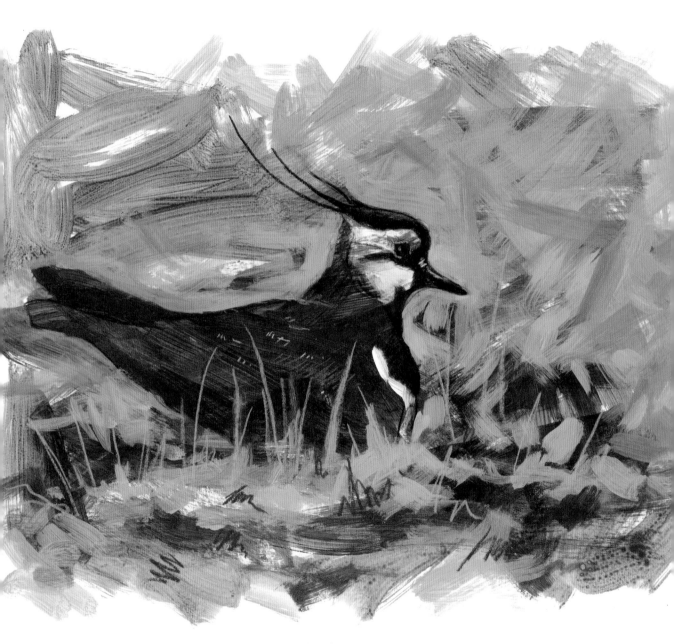

Lapwing on nest.

# INTRODUCTION

The first time I visited Oronsay, an island off the west coast of Scotland, it was to film nesting birds. My daughter was a year old, and I was beginning to realise that film-making was not very compatible with small children. I watched the lapwings swooping and diving as they displayed in the huge sky, and I made a few sketches.

I spent the next ten years learning painting and print-making, so that when I returned to the island, it was to make pictures on paper, not film. I was amazed by the wealth of wildlife there. While filming natural history for the BBC I had been privileged to travel to the best wildlife spots on the planet, but on the way I saw much destruction and mistreatment of the natural world. Here, right on my doorstep, was a glowing example of how to use land in harmony with nature.

Oronsay, owned by Mrs Frances Colburn, is farmed by the Royal Society for the Protection of Birds, the RSPB. They also farm some of the crofts on the neighbouring island of Colonsay. They use a *Management Handbook*, a sort of recipe-book of how to make great 'homes for nature'. Their focus is on species like chough and corncrake that used to be plentiful in the Hebrides, but now find themselves homeless as land is turned to new uses. The *Handbook* is dry reading, but I found the ideas fascinating. I started to write my own versions such as 'How to Grow a Peregrine' (see p. 17), and the book began.

Additionally, the ridiculous things that happened when living on a remote island, cut off from the rest of the world, were highly entertaining and, I hope, worth sharing. This book is the result of visits made over several years, although I have ordered the stories by month and season.

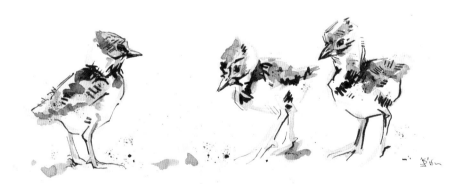

Lapwing chicks.

# RSPB

During the making of this book, I was fortunate to stay on Oronsay as the guest of my friends, RSPB managers Mike and Val Peacock. Very few people have been lucky enough to live on the island, as there is no holiday accommodation, and Oronsay is not easily accessible. First one must take a ferry to neighbouring Colonsay. Oronsay can be accessed from there across a tidal strand, but in certain weather, low tide may just not happen. With so many nesting birds, Oronsay could not accommodate a lot of human visitors, and there are no public facilities on the island.

I wanted to write this book, then, to share with people who could not otherwise experience it, the wonderful example of wildlife conservation that is being practised there. For people who want to see this wildlife for themselves, there are many more accessible Hebridean islands. RSPB reserves on Islay have choughs, on Coll there are corncrakes, and on Tiree there are breeding lapwings. Colonsay itself is a beautiful island with both choughs and corncrakes.

The RSPB can achieve impressive results on an island-wide scale, but it's possible to make a difference in a small way. Following the example of Oronsay, I've changed my lawn into a tiny hay meadow. Even a window-box can be planted with wild flowers for bees. Volunteering on RSPB reserves is another way to get involved. I would be delighted if the positive message from this wild island is an inspiration to others.

Opposite:
Oronsay. The box hedges and formal gardens
contrast with the wild landscape beyond.

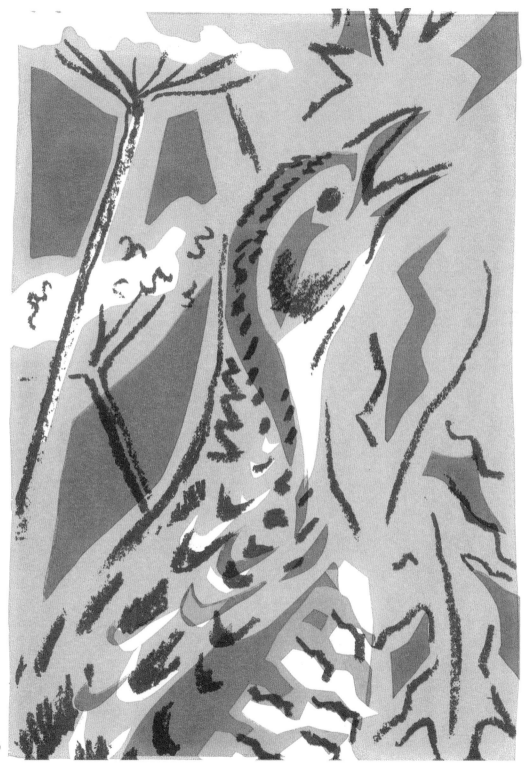

# Thanks

I would like to thank the RSPB and Mike and Val Peacock for making Oronsay the amazing place that it is. Over the last four years Mike and Val have been endlessly supportive and encouraging. They have fetched and carried me, fed me and accommodated me. Mike has shared his passion for the island, as well as (less gratefully received) some wicked practical jokes. Val has sustained me with her wonderful cooking and some hilarious stories, unrepeatable in polite company.

Thanks and respect are also due to:

Izzy, RSPB warden, for delicious cake and fabulous fiddle-tunes.

Nat, Raph, Morgan and all the other Oronsay staff for some great evenings around the farmhouse table and some memorable beach barbeques.

Mrs Francis Colburn for keeping Oronsay the wild island that it is.

Ellie Owen and Tessa Cole from the FAME project for teaching me about seabirds.

Sarah Hobhouse of the Colonsay Spring Festival for selling my work and for knitting cool hats (and tiny sheep).

Will Self from Wild Argyll for his historical knowledge and being able to do ten kayak rolls in a row.

Andrew McMorran for insights into Oronsay history and stories of Aunt Flora.

David Jardine for bird expertise.

John Aitchison, wildlife film-maker, for reading the book draft while in Papua New Guinea.

My book group for broadening my literary horizons and for the gin.

Tom Johnstone and James Hutcheson from Birlinn for bringing the book to life.

My children for getting on with life when I'm away.

Mark for always pushing me further than I have confidence to go on my own.

Opposite:
Corncrake calling.

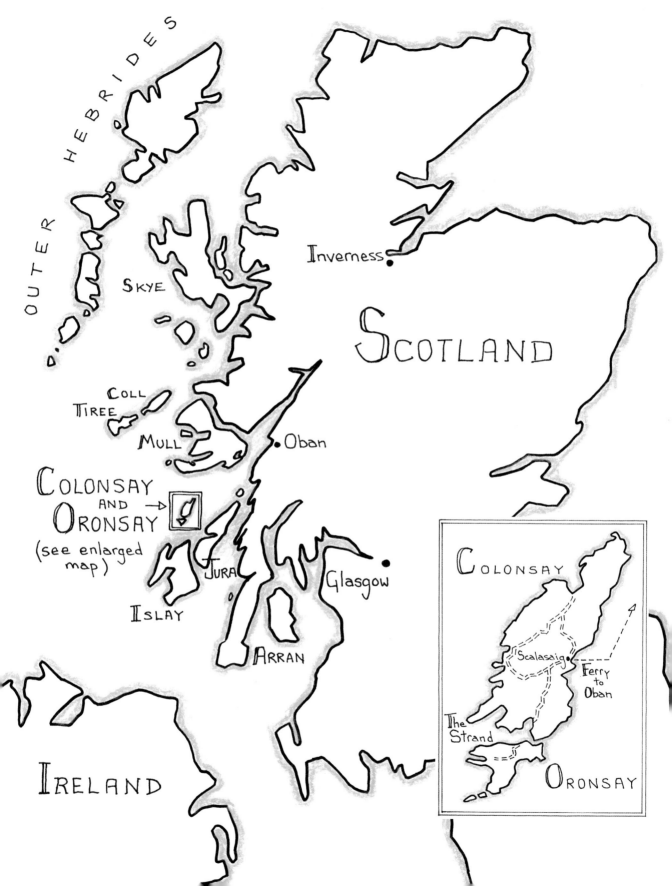

# Setting off for the Island

The Oban bus driver addressed me as 'Pal' this morning, which should have been a clue. I stop in front of a shop window and scrutinise my reflection. Because I'm over six-foot tall, I often end up wearing men's clothes, and they don't come in peach or turquoise. I'm also dressed for work, which means old clothes that will happily take a bit of paint-splatter. I wear dark colours in the field so as not to scare the wildlife. I'm in Oban, about to board the ferry to Colonsay and Oronsay, where I will spend a week painting the wildlife.

I'm pulling a heavy-duty trolley with a builder's toolbox and an army rucksack strapped to it. I'm absurdly proud of this set-up, as I can transport a week's supplies to the island without a struggle. When I'm working, the toolbox will house my paints, but now it's holding a chicken and assorted vegetables, so that I can do my share of the cooking on the island.

I suppose most sensible middle-aged ladies attempting this sort of endeavour would employ a car to ease the whole process. Most sensible middle-aged ladies have a more straightforward job that allows them to go to work in high heels. But because size-10 high-heeled shoes are mostly designed as transvestite party-wear, and also because my pictures don't yet sell for enough to justify £70 for a return car-ferry ticket, I'm walking along the street in Oban looking like a bag-lady. Or if the bus-driver's opinion is anything to go on, a bag-man.

Stickleback.

# The Strand

I take the ferry to Colonsay, then hitch a lift to the Strand. At high tide the water is several metres deep between Colonsay and Oronsay, but at low tide someone will drive across to fetch me. I will be staying for a week with Mike and his wife Val who, together with some assistant wardens and volunteers, run the farm for the RSPB.

A group of us wait on the shore, like pilgrims waiting for the waves to part. There is a crew of electricians who hope to do their rewiring job in two hours and return to Colonsay before they are cut off. There is a tractor that arrived on the ferry from Islay towing a trailer of animal-feed. Next to the driver sits his wife, as comfortable as if in her own front room. She's making a day-trip to visit Val, with whom she used to work in the Islay hospital, before Val moved here.

We all relax in the spring sunshine. As the water recedes across the sand, a speck appears on the horizon. The Land Rover looks as if it is driving on the surface of the sea, but by now the water is only inches deep. The vehicle is moving very slowly, to avoid sand and salt water being spun up into the brakes and engine. If the wheels were not hosed down with fresh water after every crossing, they would quickly rust to pieces.

The tyre-tracks are washed away by each tide, and to my eyes the sand is featureless. As we wait, I am told of the many vehicles that have been lost when they strayed from the safe path. A few years ago a builder was returning from a day's work on Oronsay in a huge digger. Low tide was after dark, and he was navigating using the lights of Pollgorm farmhouse on the Colonsay shore. Unfortunately the farmer had gone to bed, and the lights showing were those of Garvard, out to the west. The digger sank into the sand, and by the time the tide came in, all that was visible was the orange warning-light on the roof, no longer flashing. The man escaped to safety but the machine was written off.

Waders.

# A Human Population of Six

Mike and Val have been farming Oronsay for the RSPB for the past fifteen years. It's a physically demanding job, and they must soon think of retirement, but as Mike says, 'What else could I do that is as amazing as managing this place?'

Val is the sensible one. I sometimes think it is her presence here that allows all the craziness to carry on. Because she's trained as a nurse, she's in charge of fixing things for both animals and humans.

Mike is like a big kid in his enthusiasm for the island, although when things go wrong he can swear more creatively than any child. He hates sheep and loves rugby. When he reached his late fifties, Val banned him from playing the sport, so he agreed to travel to the annual Islay match only as a spectator. When Val took the dogs for a walk, however, he hid his rugby kit in the Land Rover 'just in case'. On Islay Mike played a full game, injuring his shoulder in the process. 'It was sheep-work all the following week, but I thought I'd got away with it by getting the others to do the lifting while I managed the gates.' It was only when Val opened the *Ileach*, Islay's weekly newspaper, and found a photo of Mike leaping for the ball, that the game was up. She left the newspaper open on the table when she went to walk the dogs.

In recent years, Izzy, Natalie and Raphaelle have all worked with Mike on the daily running of the farm, and Izzy has now been promoted to warden. She told me, 'My friends think I'm mad to shut myself away on a remote island in my early twenties . . . but I just love it here.'

To do the job, these girls must be able to carry a 25kg feed-sack in the wind and rain while walking sideways through a herd of barging cows, without twisting an ankle in a rabbit burrow. They have to be cheerful and resourceful. They must do without shops, without friends and family. They must live in waterproofs in winter and woolly hats in summer. For anyone who can deal with all this, then it's a dream job.

# The Island

Before I start painting, Mike gives me a tour to get my bearings. Beinn Oronsay, a 100-metre high hill at the north of the island, blocks the view of Colonsay, making Oronsay seem more self-contained. The blue dome of the sky is huge, and I feel as if the whole world has contracted to just this island.

Oronsay is 5km wide by 3km in length – small enough to feel personal and big enough not to be boring. Much of the island is flat and covered with stone-walled grassy fields that, to me, all look the same. Some have two or three gates and some are dead-ends. I will have to learn to navigate through this maze. It's strange to feel so disorientated when I can see all the way to the horizon, but it's even worse in the dark. Mike tells me of a volunteer who went out at dusk to find a mobile-phone signal and was wandering, lost, until one in the morning.

I leap out of the Land Rover to open the gates, but, embarrassingly, I often need help. Every gate has its own idiosyncrasy. One needs a downward shove before the bolt will slide, another must be lifted, and some must be pushed all the way open or they will swing shut.

Even the tracks are not straightforward. Sinking to the axles in boggy ground is a hazard to be avoided, while other paths simply vanish on the close-cropped turf. When Mike hands me the keys of the Land Rover and leaves me to it, I am a little nervous, but my apprehension soon changes to excitement.

As I explore, I begin to see the layers of interdependent relationships that make this place work. Because this is an island, a stand-alone unit, the links between people, wildlife and landscape are more obvious, but this is how the natural world functions everywhere, in a cascade of consequences. In the past, these processes happened spontaneously, but now they sometimes need some extra human intervention. Take peregrines for example . . .

# How to Grow
## a Peregrine Falcon

*Quantities correct to produce two resident birds.*

First take one steep cliff, inaccessible to predators.

Plough a field below the cliff. Obtain traditional arable seed mix and plant.

When the spring storms come and blow all the seed from the ground, swear a lot and replant. (The trick is to get the seed in the ground just before a good heavy rain shower. This will hold the seed down and encourage germination.)

Do some low-level grumbling.

Cover the field in scarecrows, preferably amusing ones. When greylag geese ignore them and try to eat the germinating shoots, chase the flock off to other fields. Repeat daily or hourly as required.

Let crop develop and set seed. Shake your fist at the rain and ask for more sun. Enjoy watching flocks of rock doves feeding on the seeds.

Observe a peregrine falcon using the cliff as a viewpoint for hunting the rock doves.

Repeat steps as above for several years, but also be prepared to shake your fist at the sun and ask for more rain. Keep checking the cliff with your binoculars every time you go out of the back door.

If you persevere, you will eventually be rewarded with the sight of a pair of peregrines displaying over the cliff, and the female incubating eggs.

Enjoy the fruits of your labours through a telescope, ideally served with a mug of coffee as a mid-morning treat.

# HISTORY

Oronsay has always been a good place to live. There is plenty of fishing and seafood, the land is fertile, there are sheltered harbours and good look-out points. Everywhere I go on the island there is evidence of those who have enjoyed this place before me.

The earliest human inhabitants were Mesolithic hunter-gatherers who lived here 5,000 years ago. Their discarded food-bones and seashells grew into tall middens, which were preserved by the blowing sand of the dunes. Analysis of these rubbish-heaps has revealed the bones of thirteen species of bird. Some of the most common are those of the great auk, a large flightless bird that only became extinct in the 1800s. Crane bones were also excavated. These birds live further south today, and so the climate in Mesolithic times must have been warmer.

The sea-level would have been higher, but apart from that, views from the island haven't changed much. As I sit in a prehistoric hut-circle above the shore looking south to Islay and east to the Paps of Jura, there is not a house or road in sight.

Today the Hebrides feel isolated, but before roads were built inland, the west coast was a major sea highway. The tides flow for six hours each way, operating as a conveyor-belt for boats. In fine weather, Ireland would only be two days away in a coracle. In 563 Saint Columba came from there in such a currach, to found his monastery on Iona. He is thought to have established the first religious site on Oronsay at the same time.

By the 800s, Vikings were settling the west coast, and the name 'Oronsay' comes from the Norse word for a tidal island. Three Viking boat-burials have been excavated here. When a warrior was cremated with his ship, charred wood and hundreds of metal boat rivets remained, becoming archaeological evidence.

I climb up to the top of Beinn Oronsay to get my bearings. One thousand years ago the Lords of the Isles surveyed their kingdom from here. All that remains of their stronghold now is a circle of fallen stones, looking out over a spectacular view.

Burnet moth.

# The Abbey

In the 1300s the Lords of the Isles established an Augustinian abbey on Oronsay and the ruins can still be found nestling under the shelter of the hill. Today, sea campion grows in the cloisters and choughs forage for insects on the lichen-covered stones, but in the 1400s this was a thriving, well-connected place.

The Abbey became a centre for stone-carving, employing an Irish stonemason, Malachy O'Quinn, who arrived from Iona. He carved the Great Oronsay Cross which still stands, 12-feet high, to the west of the Abbey. O'Quinn may well have learned his trade in cathedrals abroad, as his crucified Christ is inspired by European styles of the time. However the design on the cross-shaft has a Celtic theme of interlacing foliage and, on the back, what looks like an otter and a corncrake. This blend of international and local themes gives the carving a great sense of time and place.

The Augustinians were herbalists, and would have had a good knowledge of the island's botany. Some of the designs on the cross and the grave slabs remind me of plants that I have been drawing here. A frequent motif is the Circle of Life. This appears to symbolise the renewing of the seasons, and has a pattern like unfurling bracken. When I find an eider duck incubating her eggs amongst the fresh bracken fronds, I feel a connection with the people who lived here 500 years ago.

The Circle of Life.

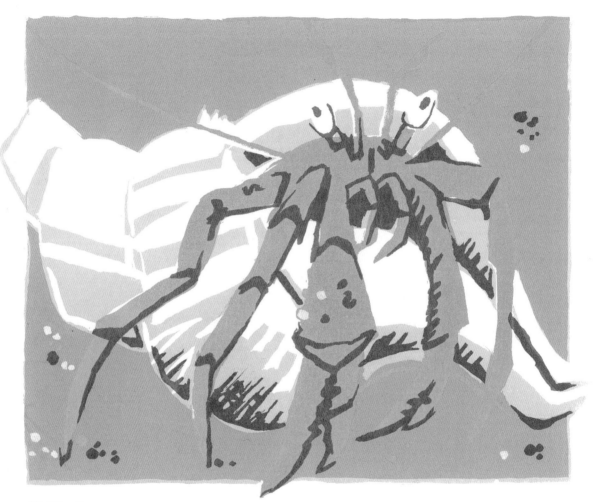
Hermit crab.

# JUNE
## *The Ferry to Colonsay*

I decide to visit Oronsay every month to get to know the island in all its moods and seasons, and thus I become a regular customer of the Caledonian MacBrayne ferry company. My husband, Mark, drops me off in Oban. The CalMac terminal has been the beginning of so many great adventures for us, most of them involving kayaks and camping. Mark looks wistfully at the black and red ferry gliding into the bay, before he heads down the road to collect the children from school.

If I were selling the crossing to Colonsay as a film script, I would pitch it somewhere between *Star Trek* and *Groundhog Day*. It feels as if my fellow voyagers and I are heading for another planet, remote from the modern world. The travellers are from all walks of life. There are schoolchildren going home for the weekend, birdy nerds with beards and binoculars, and tweedy types with headscarves, pearls and terriers.

Everyone has their own ferry habits. Mike Peacock stands on deck, binoculars to hand. On a recent trip he saw two sea-eagles talon-grappling – spinning as they fell seawards, their feet locked together. Although I would happily go for a walk in a gale, standing still and shivering on a wind-swept ferry deck while breathing in the swirling diesel fumes compounds my seasickness. In rough weather I lie down in the lounge and wait until it's all over.

After a few crossings, one starts to find Groundhog Day variations on the theme. There is always the smell of chicken curry, but some days the chef's special is Chicken Korma and sometimes it's a Biryani. There is always the sound of someone's car alarm being jolted into action by the vibration of the big diesel engines, but in rough weather these seasick vehicles form a chorus. Sometimes, racing up the stairs to get a seat in the cafeteria, I suddenly find myself in a mirrored world where everything is back-to-front. The regular ferry has gone in for repairs and its replacement does not have the cafeteria where I expect it to be.

# Livestock

On Oronsay, I set to work, trying to understand what makes this place so rich in wildlife. The main conservation workers on the farm are the cattle and sheep, which shape the wildlife habitat by their grazing. There are different mouths for different jobs. Black-faced sheep crop the field grass short so that choughs can feed, while Hebridean sheep have narrower mouths, and graze the rough hill-ground. Luing cattle grab mouthfuls of long grass in the wetter fields. As they poach up the ground with their feet, they create nesting hummocks for lapwings.

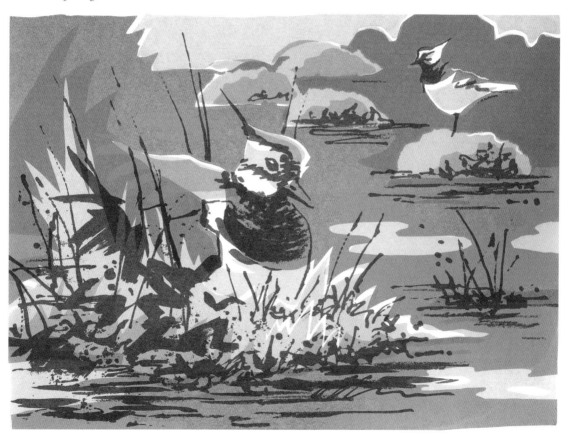

Lapwing on nest.

# Lapwings

In the evening, Izzy cooks dinner for us all. We talk about the visit of the *Hebridean Princess*. This cruise-ship had anchored off Oronsay and sent a small party ashore for a guided tour. Izzy was surprised at the emotional reaction of the visitors. She has lived here for two years now, and has grown used to her surroundings. Many of the visitors were fifty years older than her, and were overjoyed to see birds they had not seen since childhood. The lapwing's *peewit* call and swooping, skirling flight were a herald of spring for centuries, but in many parts of the country now they are only memories. In one generation, intensive farming has removed them from the countryside.

I ask Mike to explain why this happened. He told us that in the past, land was left to rest every few years, so regaining its fertility. This fallow land provided nesting places for birds. Now farmers can keep their fields in constant use by applying artificial fertilisers. The government has also paid farmers to drain any damp fields, so bringing them into production. Lastly, herbicides on the crops remove all wild plants, and pesticides remove the insects, leaving nothing for the birds to eat.

What struck me most from this conversation is that once the generation from the *Hebridean Princess* have passed away, no one will remember how the countryside used to be. The youngsters will not realise what they have lost, and that will be an end to it.

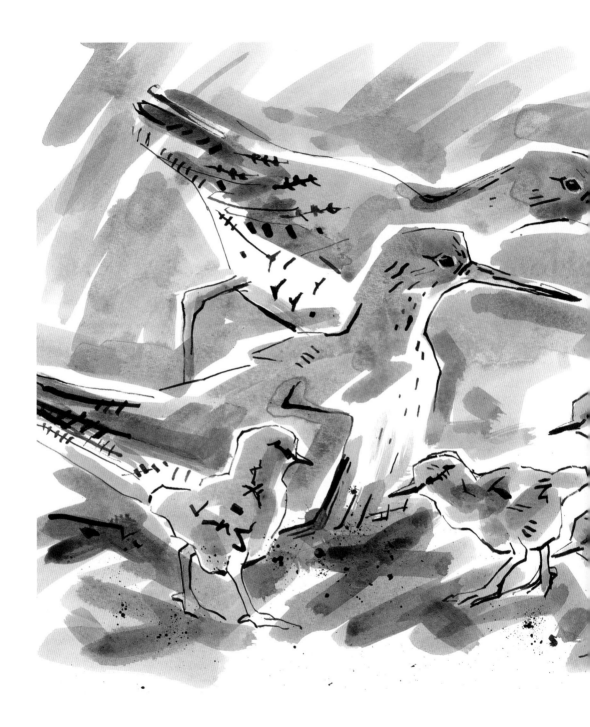

## Redshanks

Next morning I go in search of redshanks which nest in marshy ground with the lapwings. They both benefit from the way the land is farmed here. From the Land Rover I watch a family with recently hatched chicks. The parents want to escort their young to the marshy pools where there will be plenty of food. To get there they must cross another family's territory. The neighbours don't like the invasion and there is quite a commotion. A fair stushie, as people say here.

# The Corncrake's Story

At dusk there are corncrakes calling all around the farm. Until 1900, the corncrake was present in every county in Britain. In England, Mrs Beeton's *Book of Household Management* gave a recipe for them, with instructions to 'Roast before a clear fire . . . and serve on bread crumbs with a tureen of brown gravy.' In Edinburgh Lord Cockburn reported, 'I have stood in Queen Street or the opening at the north-west corner of Charlotte Square and listened to the ceaseless rural corn-cracks, nestling happily in the dewy grass.'

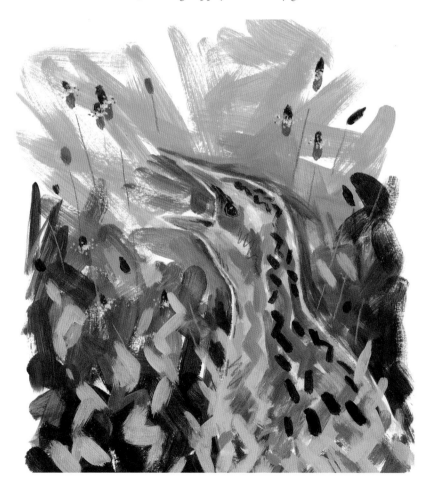

# Instructions for Growing Corncrakes

As hand-scything was overtaken by horse-drawn machinery, and then by mechanised mowers, corncrake numbers declined. By 1985 they were confined to the northwest fringes of Britain, including Colonsay and Oronsay, where only two calling males were heard. The situation was desperate. 'My job now is to run a corncrake factory,' Mike tells me. 'They are the main focus of the work here, although other wildlife benefits too.'

### How to Grow a Corncrake

Take one arable field in which to grow fodder for your livestock. This field may be grazed in winter to prevent vegetation becoming too dense.

Remove grazers by beginning of March. Add animal dung around the field edge to promote growth of nettles. Re-categorise nettles in your mind from 'weeds' to 'early shelter for corncrakes'.

The male corncrakes will return from Africa in the last week of April. Although the nettles will only be a foot high, birds can hide there, safe from predators. Enjoy their crazy craking as they establish territories.

Females return in May. For the next five months the corncrakes get on with their lives and so can you. Allow your grass to grow while the birds raise two broods of chicks, in the process eating many insect pests.

Modern farmers have moved to cutting their fodder as green silage, but this is cut earlier than hay, meaning many corncrake nests are mown down. Apply for subsidies that compensate for a later harvest, and cut in early September.

When harvesting your hay, adopt the 'corncrake friendly' system of mowing from the centre of the field towards the edge, allowing chicks to escape into cover. The adults are moulting at this time and cannot fly, so they will be trapped if the fields are mown from the outside inwards.

The corncrakes will depart by the end of September. Because your grass has had time to drop seed, you will enjoy flocks of finches in your cut fields in autumn. Feed your wildlife-friendly hay to your animals over winter, and look forward to the call of the corncrake when it returns next spring.

In 2014, 87 calling males were recorded on Colonsay and Oronsay, but they are still very vulnerable. A two-year gap in European Union funding, starting in 2015, has meant that some farmers have already taken land out of the Corncrake Management Scheme.

# Machair

I'm hunkered down in a field, hiding from the wind. I'm wearing two fleeces, a down jacket and lined trousers; it must be midsummer's day in the Hebrides. I was planning to draw butterflies feeding on the machair flowers, but a gale from the north-west is flattening the grasses and the butterflies are hunkered down too.

Machair was created over many centuries by the people who crofted this land. Where the alkaline shell-sand of the island rim met the acidic peat inland, farmers piled storm-washed kelp on top to enrich the soil. The more vigorous grasses were stunted because no artificial fertilizer was added, allowing delicate wildflowers to compete.

The rest of the island is green and lush with summer growth. Over by the house, the vegetation in the corncrake fields is now taller than I am – a foamy sea of cow parsley. Swallows skim the billowing crests like wind-surfers in the breakers.

But it is the machair field that gives Mike the most pride. He gave me a tour when I arrived. 'I think I'm in love with this field,' he said. 'Fifteen years ago when we arrived here, this was short, grazed turf, but looking at the variety of leaves, we could see it had potential.'

In March, this field is closed to grazing to allow the flowers to grow. After the flower seeds have fallen the field is cut for the hay, so removing nutrients from the system. Plants like yellow rattle also help. They are parasites on grass, sapping their strength and preventing them from dominating the field. The vegetation is only a few feet high, but rich with colour and variety. Six species of orchid, including lesser butterfly orchid, grow here.

I get back into the Land Rover, holding tightly to the door. It'll be ripped off its hinges if the wind catches it. A swallow is flying low along the channel made by my tyres, snapping at the insects that are sheltering there. I turn the Land Rover into the wind and spread out my paints on the tailgate. The vehicle is swaying about, but here I am sheltered. The swallows work their way up the field. This must be a rich hunting ground, because instead of jinking over the fence, they tilt their wings and soar back to the other end of the machair field to start their trawl again.

Opposite:

Swallows and machair.

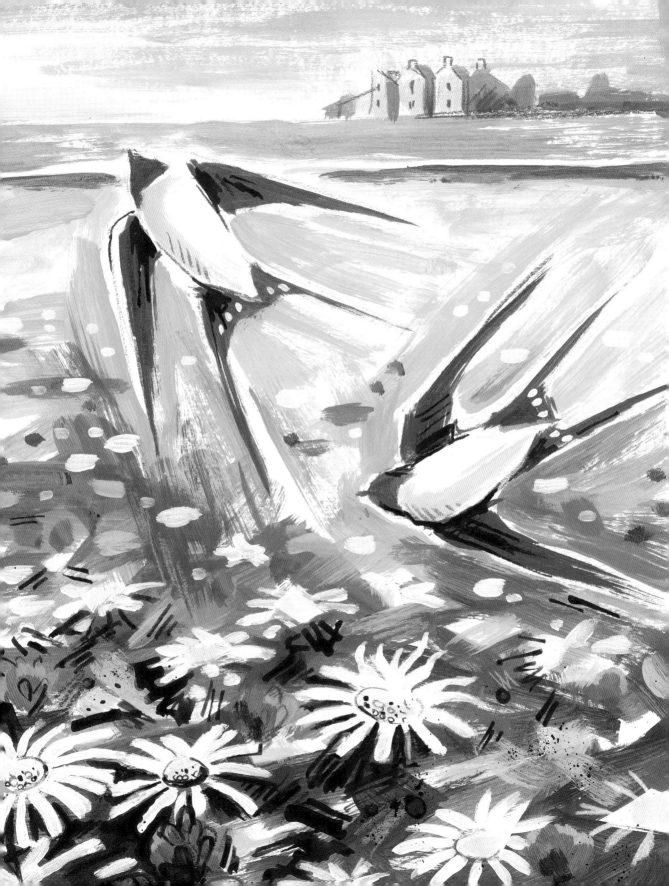

I can hear the low hum of bumblebees. With their heavy bodies they seem well adapted to this windy place. The speciality of the machair is the moss carder bee. 'The Big Ginger,' Mike calls it. They line their nest with moss and have grooved legs for combing or 'carding' it. They often nest above ground, buried in a tussock of vegetation. This makes them more vulnerable to predators, so they defend their nests vigorously. Once when Mike was pulling up ragwort, an invasive plant, a clump of vegetation started to buzz in an aggressive manner. He vacated the area swiftly!

I sit on the ground and dig my fingers into the thin mat of vegetation. There are leaves of all shapes and sizes – long and pointed, broad and round, hairy, smooth and shiny, with or without frills. It's like a book of code, a cipher divulging the secrets of the meadow, revealing which plants will appear later in the year. At the moment, ragged robin and ox-eye daisy are flowering in the damper areas, while yellow rattle and red clover are colouring the field edges. In the turf, the hairy, lobed rosettes of hawksbit and the darker, more upright, leaves of knapweed give clues to how the field will look later in the season.

The names of these plants are poetry: adder's tongue fern, twayblade and eyebright. But these are English names from my own childhood. The last Gaelic-speaker to farm this island, Flora MacNeil, has died, and the local plant names have gone with her. It would only take a day's work with a plough to send the plants the same way, but recreating a field like this from scratch would take hundreds of years. Orchids, for example, exist only in a complex harmony with a particular species of fungus. Their tiny seeds don't have enough food on board to be able to germinate on their own, so each must latch on to a mycorrhizal fungus, which will source nutrients from the soil. If the fungus is not present, the orchid will not grow.

Ragged Robin.

As I spend time working in this field, I start to appreciate its complexity, from the tiny ants working through their leafy jungle, to the skylark overhead with its ever-circling song. The skylarks must have chicks hidden nearby in a domed nest under a tussock.

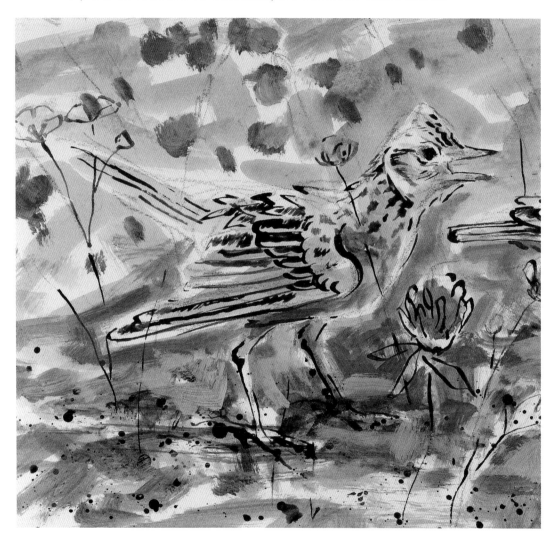

# *Snipe*

Every so often the drumming of a snipe makes me look up from my work. I think back to the first time that I came to Oronsay. Mark and I were filming wading birds for the RSPB, and had a licence to put up a hide on a snipe nest. It gave us access to a secret, hidden life. Looking down the telephoto lens, I had an intimate view into this small-scale world of insects and blades of grass. The snipe crept between them, circumspect, settling on its nest under a roof of rushes. The noise from the outside world was muffled. Dappled light fell across the bird's intricately patterned feathers as it settled down to several hours of egg incubation. What a contrast for this bird now to leave the ground and launch into the enormous Hebridean sky above.

I watch as it throws itself through the wind like a paper aeroplane, diving backwards and forwards beneath the scudding clouds and bright light. Its tail is fanned with the outer two feathers extended, fluttering in the slipstream of the dive and creating the snipe's drumming display signal.

After a few hours of painting in this open landscape, exposed to the bright sun and buffeting breeze, with all the colour and movement of the meadow and the constant skylark song, I feel exhausted. I imagine the enclosed grassy underworld providing a welcome refuge for the snipe and I pack up my paints and retreat, to find shelter of my own.

Snipe drumming.

Opposite:
Bee and clover.

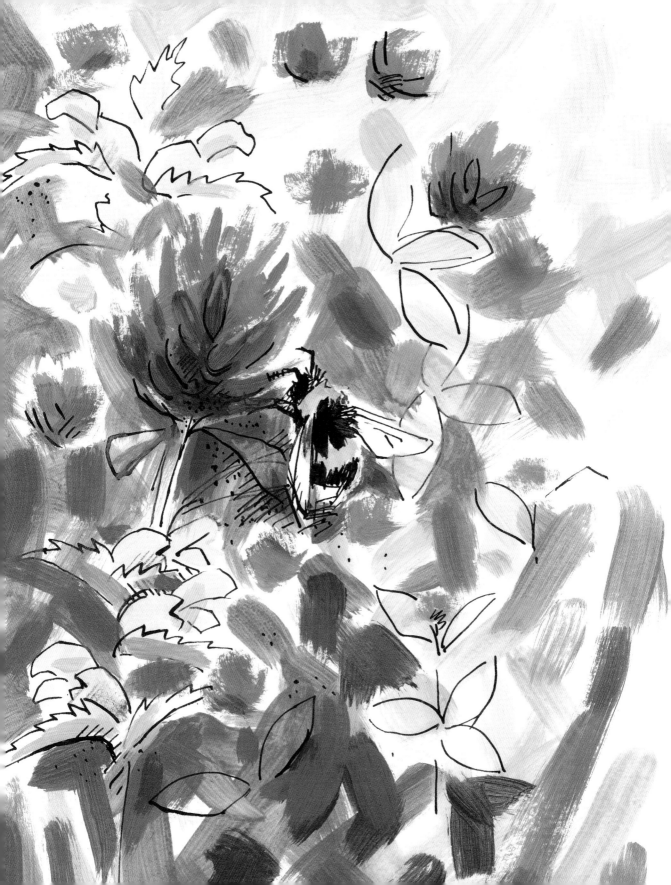

# Gathering

The air in the sand-dunes is heavy with the scent of thyme. The ground is carpeted in Technicolor with lilac harebells, yellow birdsfoot trefoil and purple clover. Orange fritillary butterflies flutter by. The colours are so bright that with the addition of a few bluebirds and a floaty dress, I could be in a Walt Disney film. A gentle breeze drifts across the dunes, carrying with it several choice expletives. The seven dwarves? No. We are 'gathering' – it's not Mike's favourite activity. I must stop dreaming and pay attention.

I look along the ridge and pick out the hidden line of people, waiting for the sheep to be driven past. A ewe is trying to make a break for it. The dogs head her off and we spring out of our hiding places to arc around and drive the bleating flock through the gate.

The sheep are gathered in this way about six times every year. This enables tups or lambs to be split off, sheep to be shorn or dosed, and any illnesses to be treated. The gathering happens over two or three days in a particular sequence of manoeuvres. Mike tells me that one year, they experimented with doing it in reverse order. 'It was chaos. The dogs didn't understand, the sheep didn't understand. We had to give up and start again.'

The whole island must be walked, which is a great way to get to know it. I am discovering hidden corners and headlands that I've never visited before. I peer over the dunes at the beach, where a turquoise sea laps the white sand. No sheep. Then it's a scramble inland, leaping over streams where the smell of bog myrtle pervades. White fluffy heads of cotton grass wave in the sea breeze and dragonflies hawk over the peaty pools. It's rough going, but I must keep my place in the line. Bog asphodels are flowering and the white petals of sundews reveal the location of their sticky, red, fly-catching leaves below. A great skua flies up, calling. If it has a nest nearby it will fly at our heads to drive us away. Its Shetland name of bonxie seems very appropriate.

Gathering is a team effort and when there are enough people the job goes smoothly. However, if a band of sheep breaks through the line there is considerable blaspheming. The whole section of hillside must be walked again, which adds another few hours to the end of a long day.

Opposite:
Oystercatcher nesting.

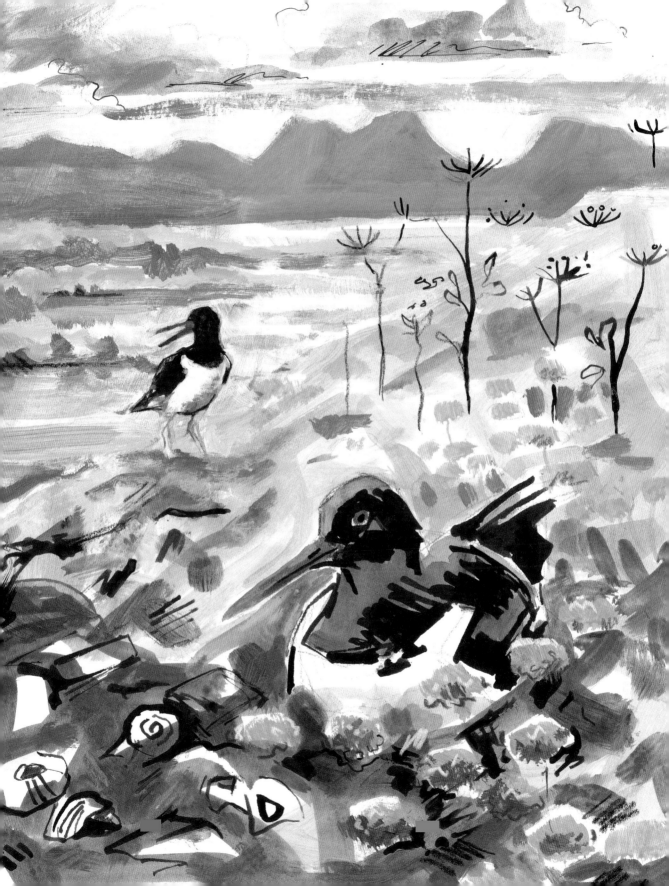

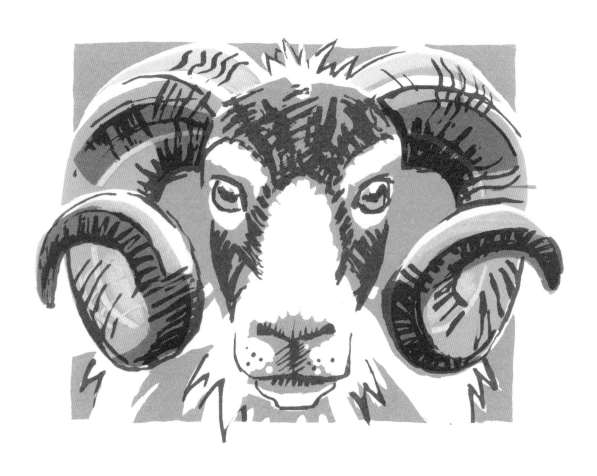

# *To Oronsay the Fast Way*

For several years I have wanted to help with Oronsay shearing, but it takes place in the summer holidays and I usually have family commitments. This year Mark is away filming grizzly bears in Alaska, but as our daughter is now twelve, she is old enough to work on the fleece-rolling team. Hurray! We arrange a lift with the shearing gang, who are leaving at dawn from the bay in front of our house on the mainland. The weather is settled. High pressure. Finally everything has fallen into place.

We are to travel in Sandy Campbell's speedboat. It isn't moored at the pier when we arrive, so we are surprised to find Sandy there, looking exhausted.

'I was trying to phone you at the house. My boat's broken down and I've had to borrow my brother's much smaller boat. It'll be a harder crossing, and quite a squeeze with the shearing lads and yourselves. You might not want to go.'

Of course we want to go! Having checked that my daughter is still game, we climb on board. Sandy had been at the Tiree Folk Festival the day before, and on the return journey, 10 miles west of Iona, the engine drive-shaft had broken. The Jura passenger ferry had come to his rescue and they had spent all night towing the boat home.

'It took forever. We were coming through the Corryvreckan against the tide, taking turns to sleep. We got home, had breakfast and came back out again.'

The shearing gang arrives in a pickup and loads machinery aboard amid much banter, swearing and joking. Big Graham is a Kiwi, in pink shades and black hoodie. He joins the gang every year during the New Zealand winter.

'My proper job is selling tankers of water back home. The main suppliers of rainwater are me or God, and right now he's taking care of business.'

We set off down Loch Sween in the pale light and out into the Sound of Jura, bumping across the sharp little waves of the upwellings. Gannets soar past above our noise and spray, just feathers and air, but faster than us. The backs of porpoises curve through the jumping water.

'Clipping sheep is pretty much the same everywhere,' says Big Graham. 'It's stuff like this that makes the experience. We always get fed well on Oronsay too. Many places now we just

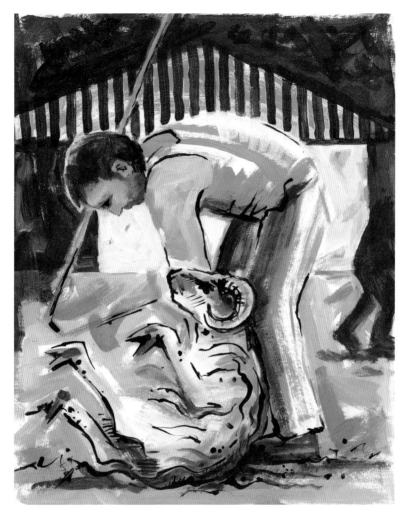

get put in a corner of a field without even a kettle for tea. Left to get on with it. In the old days the shearing was a big event. Farmers would bring out the whisky. And their daughters . . .'

We pass the Skervuile lighthouse, then enter the Sound of Islay. The tide swirls past a marker buoy labelled 'Black Rocks', and from the shore wild goats look down on us. The peaks of the Paps of Jura are cloaked in glowing mist. We pass Port Askaig where the library bus is queuing for the ferry. Past the lifeboat station, then Caol Ila and Bunnahabhain distilleries. Rhuvaal Lighthouse marks the exit from the Sound of Islay, and we're out into the Atlantic, all sunlight and spray, with Oronsay ahead of us across a rolling swell.

# Shearing

A cooked breakfast awaits us at the farm, and then to the business of the day. Noise fills the big barn – the whirring of clippers, the bleating of sheep, the herders' hollering and whistling, shouts of warning at a loose sheep, swearing, laughing and bragging. The gang keeps up a good pace, always with an eye on each other's work-rate, the competition fierce. They are paid by the sheep, so the speed doesn't slacken. My daughter works with Izzy on fleece-rolling. It's hot and dirty work, pulling matted dung off the fleece, rolling the wool into a tight bundle and packing it into a huge sack. She has to be on her toes, picking up fleeces as soon as they fall, sweeping up the discards and watching out for shorn sheep careering past as they're released.

I find a quiet corner and get to work with brush and ink. The shearers are moving so fast that it's difficult to get a picture of what's happening. Luckily clipping is a repetitive process, and after a while I start to see the pattern. The sheep is tipped onto its back and the short wool is removed from the belly and around the tail. With sweeping strokes the shearer works up the left flank and the fleece starts to fall away like frothing yellow cream skimmed from milk. The sheep's head is tucked between the man's knees as he clears the wool from its back and turns the animal. Before I know it the fleece is on the floor and the naked sheep is making a dash for the door. Looking vulnerable without their thick coats, some look back to check what happened to their clothing. Even the old ladies kick up their heels and pronk, jumping high into the air as an instinctive, ancient response to predators.

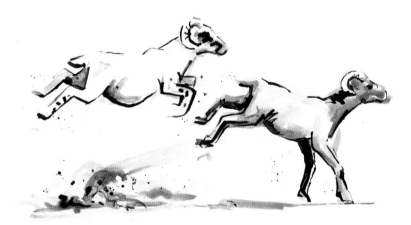

I follow the ewes outside. I don't suppose they feel self-conscious, but they must feel chilly with the wind around their bottoms. I am reminded of life-drawing class when the model emerges with clothes removed. There is something very personal and honest about seeing the naked body with its story of a life lived. When drawing humans, the classically perfect bodies are less interesting than those with a few lumps and bumps, and it is the same with these sheep.

They no longer all look the same, but with their folds and crooks and hollows and saggy bits, they appear as individuals. Some have low rounded bellies while others are more compact. Many have a hollow behind their ribs, which disappears when they bleat. They were brought up from the fields early this morning and their stomachs are empty.

When the gates are opened they each find their way back to their own field to feed. We have a feast waiting for us too. In the farmhouse kitchen Val has covered the table with quiche, pizza and salads.

By late afternoon, 550 sheep have been shorn. There is still time for a swim in the sea for the bravest of us, before the shearing gang climb aboard the boat for the return journey. They have another 400 sheep waiting on the mainland before their day is finished, but we are exhausted, and glad to fall into bed in the farmhouse.

# Moths

Last night Mike put the moth trap out. An ultraviolet light attracts the insects which then shelter below the lamp in a large box. We bring it to the office table and gather around like expectant guests at a banquet, rubbing our hands in anticipation. No-one knows what entomological treats are inside. The top is carefully opened – the crust on a mystery pie. Moths crawl out and the air is full of delicate fluttering. Laughing, we dart to catch them against the window panes.

These moths are camouflaged to fit in every nook and crevice of their surroundings. They pretend to be tree bark, twigs, lichen and even bird poo. Each insect must be identified and listed. There are thick tomes in the middle of the table, and we set to work. The scientists amongst us get stuck into the main course of small brown speckled moths with big names, but like a child who is only interested in the puddings, I am distracted by the bigger, more colourful species. The angle shades moth is lilac and green, and the elephant hawk moth is a saccharin pink. The patterned wings of the garden tiger moth flash open to reveal bright orange with blue spots.

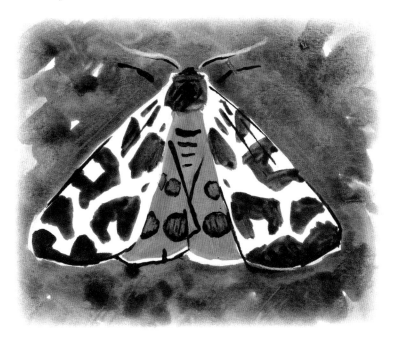

Garden tiger moth.

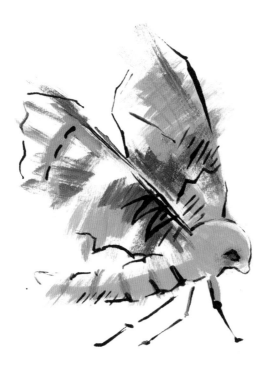

Poplar hawk moth.

Once I've had my fill of the sugary colours, I go back to the more subtle delights of the brown moths. Identification starts with looking at wing position. Some moths hold their wings out to the side like a butterfly, others fold them together over the body like a tent, and with others they are angled backwards like a streamlined fighter jet. Their names give a clue to the variety of forms. The spectacled moth has white circles around its eyes. The beautiful golden y has that letter emblazoned on its wings. The burnished brass moth has an iridescent green sheen, along with a mohican 'hairdo' and taffeta ruffles down its back. Other names are more fanciful: true lover's knot, clouded bordered brindle, buff ermine and smoky wainscot.

Once we have counted each species, it is released into the undergrowth to hide until nightfall.

Moths are great indicators of what is happening in the hidden corners of our world. Many are adapted to live on a particular plant, so by comparing the moths trapped each year we can get a better picture of what is happening to our surroundings.

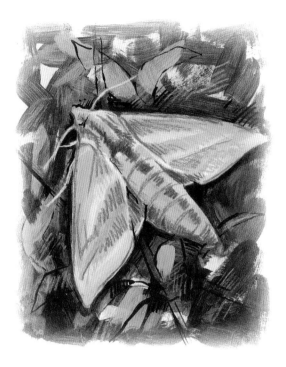

Elephant hawk moth.

When I was making wildlife films for a living, the animals that received most attention were big predators like sharks, tigers and wolves. Now I am finding that the small creatures at the bottom of the food chain are far more interesting and important. If they disappear, the whole predation pyramid above them collapses.

As I have found out about these 'creepy crawlies', I have discovered stories every bit as fascinating as those of bigger beasts. On the shore one day I noticed some painted lady butterflies. I thought that two were flying around me in circles, until I realized that it was many different butterflies arriving over the waves and flying on past me. I think of butterflies as delicate insects, but these painted ladies were migrants from Africa. As I sat watching, they flooded in from the sea, landing on thrift flowers to refuel. In years with favourable weather conditions, huge numbers hatch out and fly north, laying eggs and hatching further generations as they go.

47

# Flight

I am crawling on my hands and knees, looking for a skylark nest. I saw the bird land near here with a beakful of food. The nest must be hidden under a grassy tussock. Lying on the ground, I enter the skylark's world. A grasshopper 'chickers' nearby and ants scurry past. This miniature landscape provides the birds with perfect shelter from the weather, and a plentiful supply of food.

It also makes for an unusual airport lounge. I am waiting for the scheduled flight from Colonsay to Oban, via Islay. The Colonsay airstrip is situated at the edge of the coastal sand dunes, a place where, for thousands of years, humans as well as skylarks have sought shelter and food. A Viking burial and Norse settlement have been excavated here.

I can hear the skylark singing high in the sky, as well as the approaching Islander plane. For several years I have wanted to see this landscape from a different perspective, and today is my big day.

The name of the pilot is Julie Angel. Yes, really. I take it as a good omen, sling my bag in the back and listen as she rattles through the safety demonstration, reminding us that in an emergency we should exit the plane away from the spinning propellers. There are seats for eight passengers, and I take the place vacated by the District Nurse who will be working on Colonsay today.

The engines roar, and after a short taxi we are airborne. Within seconds we are much higher than the skylarks, and everything looks different. I try to suck in every moment of this experience, but it is all so new and confusing that it takes me a while to adjust. The unit of measurement is no longer a tussock, but rather a long ditch, a fence-line, a white toy house. That sinuous dark line must be a burn, looping with rivulets and peaty pools into the Strand. It is high tide, and turquoise water covers the sand, lapping around grass-green islets. We crest a hill and Oronsay is spread out below us. I have only time to see the ant-like dots of Hebridean sheep and a flock of white birds flying below us, before we are already crossing the coast. From here, the patterns of the shoreline resemble those of encrusting lichens, or a patina of algae. I'm not sure if I'm looking at something minuscule or massive. It seems unreal, although this perspective is just as real as the view through a microscope, or our normal earthbound experience.

Flying over the open sea gives me time to get my head together, and then we reach Islay. Cows on the beach below look like lice in the seam of a giant's clothing. The hillside bracken becomes a rough fur hide. The giant body of the island is pockmarked with signs of past encounters: with eczema from heather-burning, the scratches and scrapes of peat-cutting, and the long scars of sheep tracks. Where the land has been grazed thin, the mangy old pelt stretches taut over the bones of the hills. This giant is ancient, but alive. We fly on, over his creases, folds and wrinkles, over the wriggling arteries of rivers. Then gradually his sinewy, wild old form becomes clothed in a patchwork coat of fields, in the straight lines of roads and hedgerows. The central part of Islay is rich farming land and the wild body of the island disappears from view.

Skylarks singing.

I am brought back to reality as we bump down onto the runway and everything returns to its usual perspective. Houses are tall once more, skylarks fly above, not below, and the horizon is seven miles away. The everyday business of humans regains its normal importance. Suited whisky executives leave the plane and make way for Islay passengers. An old man with a stick, breathing heavily, is helped on board. A pregnant girl gets in too. This air service allows Islay residents to visit the hospital in Oban and return home on the same day. The flight will be thirty-five minutes, instead of the four hours it takes by ferry and road.

The plane is lightweight, with walls thinner than a modern car. The doors close with a bang, not a clunk. The dashboard is a mass of old-fashioned dials and meters, and I am taken back to my childhood when we made aeroplanes from cardboard boxes on the living-room floor. As we taxi down the runway on our three wheels, it's like being in a Reliant Robin. But then the pilot pushes the throttle and we soar back up into that enticing world of suspended disbelief.

We climb higher now and at a thousand feet the view is different, allowing a fresh perspective on time as well as space. A cluster of rectangles reveals the ruins of an old township hidden amongst the forestry. The pale loops of oxbow lakes show how a river has meandered through the centuries. Flying up the west coast of Jura, we pass below the crumbling quartzite peaks of the Paps: mountains that have stood here for millions of years. We cross the deep, dark water of the Corryvreckan. The ebb tide pours through this gap, carrying huge, rotating plates of water from the open Atlantic into the Sound of Jura. Further north, white water surges like a river between the smaller islands. A mere ten thousand years ago when the glaciers receded, they left great gouges from north-east to south-west which flooded into a maze of sea-lochs. I imagine Vikings passing between these islands twelve hundred years ago, in search of sheltered water beyond. On the hilltops below I can see the neat circles of Iron-Age forts, built for protection against raiders. Mirroring their shape, next to them in the lochs, are the circles of modern fish farms.

We start our descent to Oban: over the town's large rubbish tip, over the ferries in the harbour and the cemetery, back into our own small world, which seems so big from ground level. Like the skylark, I seek shelter and food down here, but I try to hold on to the bigger picture. I've seen over the horizon, been challenged by new perspectives of both scale and time. After this flight I feel the need to tread more lightly on the ground.

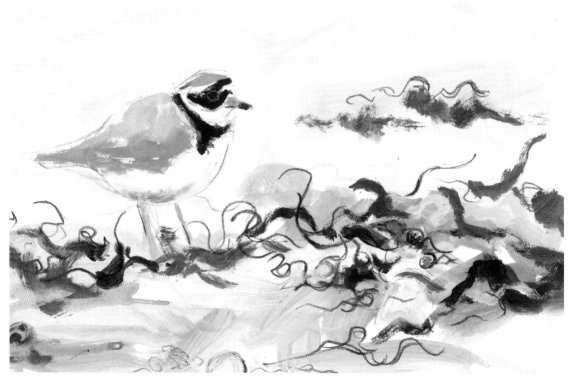

Ringed plover.

Shore crab.

# Crossing to Oronsay on Foot

Iusually arrive on Oronsay in the Land Rover. At low tide someone drives across the Strand to fetch me, running some errands at the same time. It's always a rush and we glance constantly at our watches, anxious to return to Oronsay before the tide cuts us off. Now it's the summer holidays, I'm taking my children to visit the island, and we decide to cross the Strand on foot.

We wear our walking boots and leap over the puddles. The huge sky is reversed in the sand's sheen, with a scribble of worm-casts doodled across the reflection. My son dawdles, picking up tiny crabs patterned in shades of green.

The deepest part of the crossing is near the Oronsay shore. There's a channel here that rarely dries out and I'm looking forward to the adventure of wading through it.

By the time we reach it, however, the tide is low, and I am sad that we only have a short distance to paddle. I take off my boots and my disappointment instantly vanishes. The water is painfully cold. I walk as quickly as I can without splashing, like a heron, plucking each foot up above the surface and making exaggerated steps to cover the distance as quickly as possible.

We brush off the sand with our socks and don our boots. There's another kilometre of rough track to walk until we reach the farm, but at least that will restore the circulation to our feet.

Pollock.

# Volunteers

I've brought my children to the island to do some volunteering for the RSPB. Mike always has plenty of tasks saved up for us, such as cleaning out the kennels or pulling up thistles. There are also fun jobs like bottle-feeding orphaned lambs.

RSPB volunteers come from all walks of life. On Oronsay I've met retired civil servants, inner-city mums and backpacking students. All are delighted to be staying in such a beautiful place and they throw themselves into the work.

Mike recently sent two of his volunteers, Richard and Gill, to search for rare marsh fritillary butterflies. One of the back fields is being managed to encourage the growth of devil's bit scabious, the food plant of the caterpillars. The volunteers returned with news of a carpet of orchids that they couldn't identify.

'I couldn't believe it when I went to look,' Mike told me. 'They'd found about 160 Irish ladies' tresses, a completely unrecorded orchid for the island. The plants must have been dormant in the soil for many years, and when we changed the conditions in that field, they all flowered.'

The delicate white flowers have a vanilla fragrance and are named for their resemblance to twists of braided hair. They only grow in a few places in the British Isles, so finding them here has caused a lot of excitement and some press coverage too.

Irish ladies'
tresses orchid.

Oystercatchers.

# Otters

A friend once asked me, 'Why do you get so excited about seeing otters, but only glance at seals?' I suppose it's because otters are so difficult to find. The bigger, more confident seals are curious about humans, and often bob in the waves, trying get a better look. I only see an otter when it hasn't seen me first. My best sightings have been while kayaking, as otters seem not to recognise the floating me as human. I try to keep downwind, but if the breeze eddies and they catch my scent, they just vanish. Unlike seals, otters can only stay underwater for a few minutes, but they often hide under floating seaweed, with only eyes, nostrils and ears showing.

This means that an encounter with an otter is usually unexpected. Mike told me of his most recent sighting, when he was parked above Chough Beach. An otter appeared at the water's edge and went into stealth mode, low in the waves like a crocodile.

'There were a load of eider ducks on the sand with a crèche of chicks, and all of them legged it as fast as they could along the shore. I thought the otter was hunting, and so did the ducks. It came out of the water and was followed up the beach by about forty oystercatchers, all calling and making a fuss. A real procession. When the otter disappeared into the sand dunes I realised why it was acting so stealthily. It must have had a holt with cubs, hidden above the beach.'

# Basking Sharks

High summer is when the *cearban*, or basking sharks, arrive on the west coast. They are the largest fish in the North Atlantic. The first time I saw one I thought it was two separate animals, such is the distance between tail and dorsal fin. They are gentle giants, swimming lazily on the surface of the summer sea, not really basking but, mouths agape, sieving plankton from the sunlit water.

Some years only a few turn up, but this year, on a boat trip from Oronsay to the Colonsay pier, Mike counted thirteen. Encouraged by their placid reputation, Izzy wanted a closer look and jumped into the water.

'Mike started humming the Jaws theme music,' she told me. 'He wanted me to swim towards the shark so he could take a photo, but when that tall fin turned in my direction I just wanted out. Our boat is five metres, and the shark was twice that length.'

Last century, basking sharks were hunted for the oil in their enormous livers. Now scientists from Scottish Natural Heritage and Exeter University are tagging them to discover where they disappear to in winter. It was thought that the sharks' store of oil would sustain them through a hibernation on the bottom of the ocean, but now the satellite data has tracked some of the Hebridean sharks to wintering grounds off North Africa.

I have been close enough to them while kayaking to touch them with my paddle, but they still seem utterly mysterious, providing all the excitement of a mythical sea monster.

Opposite:

lobster.

# Fishing

When we take the boat out in summer we'll often drop a few lures in the hope of mackerel. We follow diving gannets to find the shoals. The fish are so dense that sometimes we pull in four on one line, flashing and thrashing on the deck. Izzy guts them and throws the heads overboard. If we're lucky a tope, a type of shark, will come in after the fish heads.

'Once a tope took one of the mackerel that I had on my line,' Mike told me. 'The shark was so big, it started towing the boat along. Eventually it rose up to the surface and shook the hook free.'

As we speed through the waves, bottlenose dolphins come in to bow-ride. They leap out and make a huge splash on re-entry, soaking us in spray.

Summer also brings less welcome visitors. Lion's mane jellyfish look like disembowelled entrails, beating their way through the water. While swimming I brushed against one, and suffered for five hours afterwards. It felt like mini-electric shocks were attacking my whole body. A very unpleasant experience.

Gannets
diving.

59

# Sea Tank

Having the children on the island gives Mike the perfect excuse to set up his big saltwater tank. With mussels to filter the water, a pump to aerate it and a daily bucket of cold fresh sea-water, it runs beautifully. We go to the strand at low tide to search for potential inhabitants. To my uninitiated eye, the sandy pools look empty, but as we search under clumps of sea-weed, shrimps and flat-fish shoot out, and crabs scuttle away. The children stalk sand gobies, Mike goes into ecstasies over orange sponges, and Izzy finds a colony of snake's lock anem-ones. We are forbidden from bringing back shore crabs to the tank, as they eat everything in there. Nothing would remain but one big fat crustacean.

Yesterday was full moon, so today's tides will be big – three and a half metres between high and low. At very low tide we can reach animals that normally live in deep water. In our wetsuits we wade in the channels between the islands, pushing aside leathery kelp to discover squat lobsters, sea slugs, cowries and, our most exciting find, a little cuttlefish. This changes colour from a peeved purple to a resigned and pragmatic yellow when put into the yellow bucket.

Cuttlefish.

The seawater tank is situated in the bathroom. Anyone who needs to pee, first has to evict the row of people who are sitting on the edge of the bath, watching fish. The tank is like the Garden of Eden reinvented: a brand new world of plants and animals waiting to be discovered.

A shaggy unkempt spider crab suddenly feels the need to clothe itself. It takes up residence on an orange sponge, tears off chunks, adds something sticky from its mouth and fixes the decorations all over its body as a gaudy camouflage.

Shrimps hide under the sand with only their wispy tentacles protruding. Shaking like wet dogs, they wriggle free, all their legs running through the water in a crazy doggy paddle. Multitasking anemones shoot out one arm to grab a passing shrimp, and hold down a tiny fish with another.

Hermit crabs protect their naked bodies by carrying abandoned seashells on their backs. Their starter homes are tiny periwinkle huts. As they grow they move up-market to top shell houses, and eventually to whelk palaces. If another hermit passes by with a more desirable residence, a tug of war ensues, with eviction for the weaker tenant. Several crabs have encouraged sea anemones to stick to their shells. By combining forces, both can scavenge each other's food scraps. Together they're also more of a force to be reckoned with. With their anemone millinery set at a jaunty angle, the hermits graze delicately on seaweed, using their pincers as cutlery: a group of fierce ladies at a tea party.

The cuttlefish flies past like a miniature pink elephant with wings, while the gentle sea hare, with its long dark-tipped ears, moves more slowly than a tortoise. This surreal world exists only a short distance from the back door, yet every day we're discovering creatures we didn't even know existed.

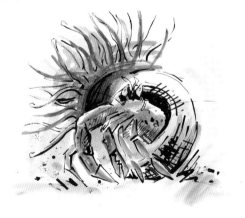

Hermit crab.

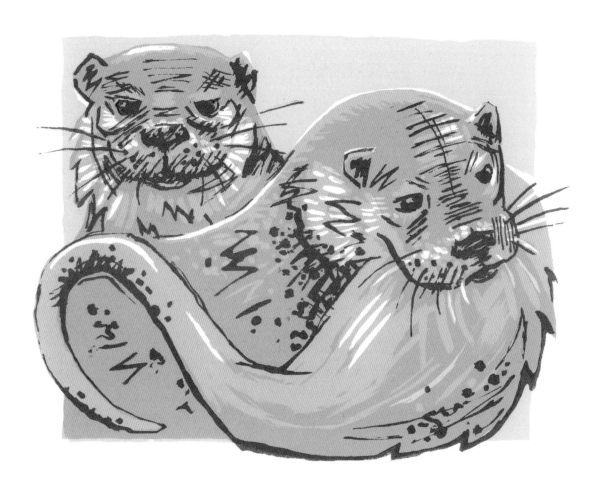

# *Leviathan*

I'm taking pictures to sell in the art gallery on Colonsay, so on this visit I have the luxury of a car. We line up bumper to bumper at the pier in Oban, waiting to board the ferry. The ship's projecting bridge windows give it the look of a hammerhead shark, but the huge bulk of the vessel is more whale-like. With bow smilingly agape, it is waiting, patiently, to swallow us all.

Inside, the air smells stale. I snooze on the lounge benches as we plunge and shudder through the waves. Poor Jonah, I think.

We are called back to our vehicles, and wait in the ship's cavernous belly. The structural white ironwork curves above us like baleen, while passengers in krill-pink anoraks dart between the cars. Deck-hands gather around rusting winches. They throw a thin rope with a knotted end ashore, which drags a spaghetti of hawsers up to the jetty. As the leviathan is restrained, there are rumbles and belches from the shuddering engines within. Car engines start up and the air is filled with noxious exhaust fumes. Jonah had to make smoke to persuade the whale to release its human cargo, but I'm sure the smell of diesel would have been as effective. The bow door opens slowly and cars and lorries disgorge onto the Colonsay pier.

The noisy, smelly car-deck is not somewhere I'd like to linger. Recently Izzy was bringing a transit van to the island. On docking at Colonsay she climbed into the back to fetch something.

'The door swung shut, locking me in. I shouted and banged, but it's so noisy that no one heard me. I thought I'd be travelling all the way back to Oban shut in the dark, but eventually one of the deck-hands came to my rescue. What a relief!'

Shrimps.

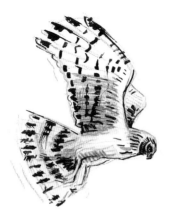

# *Finches*

I arrive on Oronsay to find everyone in the yard with a cement-mixer, renewing the cattle-handling system of gates and fences. Everyone except Izzy. She is stuck inside on office duties, as she's pulled a tendon. It's her own fault. She went to the post-rugby match ceilidh on Colonsay last month. This took place in a field, and while 'Stripping the Willow' she stepped in a rabbit burrow. She can't put weight on her foot, so is hobbling around the office, cursing.

At least she has a good view from the window to where a flock of twite, linnet and skylarks are feeding in the stubble. In the spring Mike sowed some traditional crofting seed from the RSPB farm on the Outer Hebrides. (He put Val's old nursing uniform to good use as a scarecrow.) The seed was a mix of bere barley, rye, and Uist oats, traditionally used by crofters to provide winter feed for cattle. Because no herbicides were sprayed on the crop, wild flowers such as charlock, bugloss and fat hen grew amongst it and dropped seed. The crop has been harvested but the seeds remain, providing food for the finches, which in turn play their part in the food-chain. They all take off as a hen harrier glides low over the stone wall, hoping to surprise a feathered morsel.

Top: hen harrier.
Bottom: twite.

# Starlings

Starlings also feed in the stubble. Elsewhere in the UK their numbers have declined, but the more traditional farming methods on Oronsay provide plenty of food for them. The stone sheds around the yard provide nesting holes, and the fledged young now gather in flocks, wary of the local sparrowhawk. In the morning I watch them from the bathroom window as I brush my teeth. The youngsters are not yet confident flyers. They negotiate the fresh autumn wind on the roof ridges, skidding on the slates, squawking and squabbling.

# Dogs

 Starlings are great mimics and some have even learned the whistles used to direct the sheep-dogs. Mike told me that one bird would sit on the barn whistling, while the confused dog ran in circles in the yard below. I am also learning the commands to the dogs. A shout of 'Come by' means, 'Go to the left'. 'Away to me' means 'Go to the right', while 'Lie down' is self-explanatory. The dogs are essential when farming sheep on the open hill. They can race over rough ground to gather a flock and herd them towards a gate.

In September the sheep are brought into the yard to separate the grown lambs. Some of the older ewes stand their ground and it takes a confident dog to shift them. Each dog has its own style. In her prime, Tess had a good turn of speed. If a sheep needed to be caught, she could grab the animal by the shoulder-fleece and throw it over, holding it until Mike caught up. Now, though, she is retired and lives in the comfort of the farmhouse kitchen. Ben, a heavier dog who relies more on strength, has taken her place in the yard kennels. He obeys Mike, but is quite intimidating to visitors like me. Saphi, who has one blue eye and one brown, is the youngest dog. She is still learning the farm routines, and waits patiently in the back of the Land Rover until we need her.

Saphi.

# The Old Bulls

There is a gaping hole in one of the field walls and a pile of rubble on the ground. The island's two bulls have been put to the cows, and Eriskay, nicknamed the Devil Bull for his ear-tag number 666, has broken through the wall to fight with Expectation. Furthermore, during his escape he attempted incest by trying to mate with one of his own daughters.

The two bulls are not related. In normal circumstances they breed with each other's daughters so that genetic diversity is preserved in the herd. At the end of the breeding season the bulls will go back to the same field to live peacefully together until next autumn. Last year, however, when Mike was driving them back home, Expectation got his neck under Eriskay's flank and heaved him over the fence. He then broke the fence and pummelled the other bull who was on the ground. 'They are enormous animals,' Mike told me, 'they weigh nearly a tonne. I knew that if I didn't intervene, Eriskay would be killed, so I just hit Expectation as hard as I could on the nose until he ran off, leaving me shaking. When I eventually got them back in their field, Eriskay retaliated and beat the s\*\*t out of the other bull, and since then *he* has been the dominant one.'

In autumn the bulls move into the field outside the house. The day's work finishes at dusk, and Mike can catch up with all the TV he's missed through the summer. One dark evening he was watching *Jurassic Park*. Just as the dinosaurs were chasing the humans through the jungle, the picture started to flicker and fizz. Mike was startled to see an enormous head appear at the window with a baleful eye staring in. It was Eriskay. He had discovered that the satellite dish was at the perfect height to reach the itch between his shoulder blades.

Eriskay.

# Choughs

There are thirteen breeding pairs of choughs on Colonsay and Oronsay. They used to be widespread on the Scottish west coast, but now there are only about one hundred pairs left here. They are cousins of the hooded crow, but with their bright red bill and legs they are like a circus version, clown crows, always swooping, tumbling and playing in the wind.

### How to Grow Choughs

It is not possible to grow single choughs as they are social birds, learning their survival skills from each other, so a family unit is the minimum quantity.

Take some grassland in an area with little frost and graze it to a short turf, using both sheep and cattle. Do not treat your animals with drugs such as Avermectin, as it will make their dung sterile and of no practical use to recycling insects.

Allow one pair of choughs to feed on insects in the cowpats and surrounding grassland. Do not spray your fields to kill the fat grubs of cranefly (a particular delicacy).

To assist with winter survival of your pair, provide one steeply shelving beach, sheltered offshore by a weedy reef. Storms will wash kelp onto the beach, but the reef will protect the beach from smaller tides, preventing kelp from washing away. This provides a delightfully smelly habitat for kelp-fly maggots, which chough find delicious.

Feed your cattle out of doors in winter to continue the supply of dung-recycling insects.

Provide one cliff with deep holes or caves away from any rain. Don't allow human disturbance near caves from the month of March. Your choughs will collect heather from the cliff-top to build a nest, and sheep's wool to line it.

Maintain the health of your grassland, so providing a steady supply of insects to feed the hatched chicks. Once fledged, the young birds will be taught by the adults where to find the best food – you can leave this bit to them.

If your pair breed successfully they will stay together for life. The youngsters will be left in a 'babysitting' flock of young birds for three to four years, until they themselves are old enough to breed.

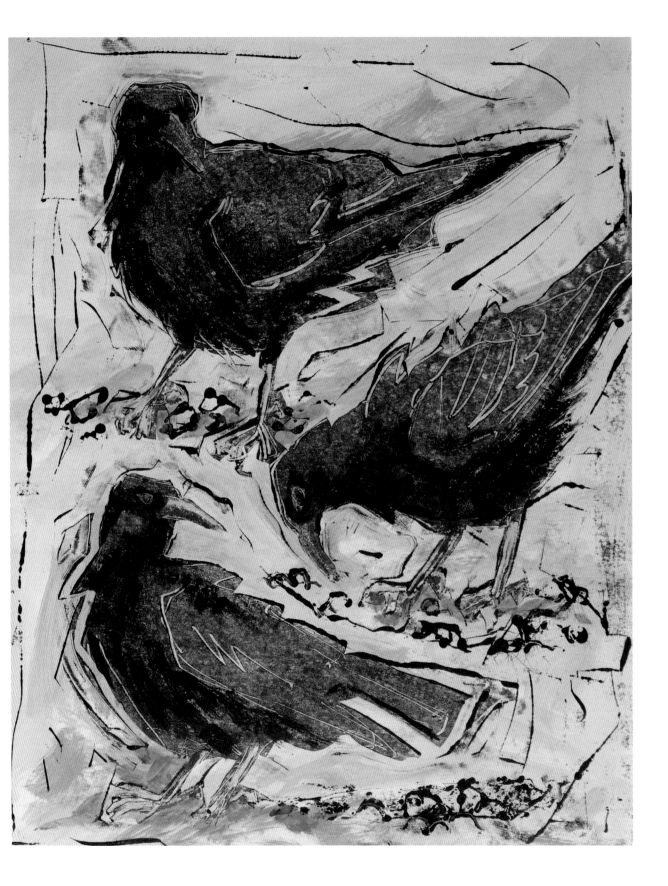

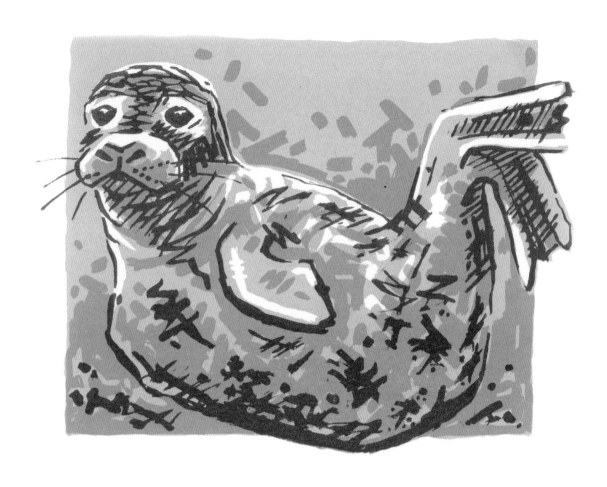

# OCTOBER
## *A Walk in the Dark*

The ferry to Colonsay is full of road-maintenance lorries. It is 7 pm when we arrive, and as I disembark I pass men silhouetted in the headlights. Huge machines rumble and cans of tar are heating on roaring fires in the dusk. Their plan is to work through the night to repair the harbour road, before catching the morning ferry home.

I told Mike that I would be at the Strand by nine, when the tide would allow him to cross from Oronsay to fetch me. It's a three-kilometre walk from the ferry to the Strand. Although I've packed enough clothes for every kind of autumn weather I have my trusty trolley to carry the luggage. 'Don't worry, it'll be a walk in the park,' I tell Mike on the phone. Of course at this time of year, it will also be a walk in the dark.

As I leave the noise and street lights behind and head into the blackness, my biggest concern is that someone will see me and think me bonkers. A few cars pass, and I step onto the verge, head down to preserve my night vision. I'm relieved that no one stops to offer me a lift, as my resolve might falter. Walking briskly, I pass the last few crofts with their reassuring smell of peat smoke. Uncurtained windows cast warm squares of orange light, each revealing a domestic scene. I set to pushing my trolley up into the hills like an old fishwife, and am glad of the darkness. I think of Sweet Molly Malone. '*Now her ghost wheels her barrow, Down the streets broad and narrow . . .*'

I wonder if I will hear birds migrating overhead, but when I stand still and listen there is only a rustling in the reeds nearby. Is that just the wind?

Bladderwrack seaweed.

In my mind I run through the logical dangers of walking across Colonsay in the dark. I can see the silhouette of the ancient Viking hill fort against the sky and I'm sure plenty of people died horrible deaths here in the past, but the idea of ghosts doesn't really bother me. At this time of year on the mainland it's the red deer rut, and testosterone-crazed stags are roaring in the glens. The sound is as scary as a tiger's roar, but I don't think there are any red deer on Colonsay. I pull out my head torch, and sweep the beam around me. There are only cowpats on the road.

Uh-oh. I hadn't thought about cows. At home they like to stand on the dry road at night where the tarmac radiates back some residual heat from the day. They are always reluctant to move, even if you drive right up to them, and we often have to manoeuvre around them in our car.

But now it's me on my own, and no car. Sheep have a reflective surface to their retinas, so in torchlight their eyes glow green, way before you see the actual animals. While this is spooky, at least it is reassuring to know where they are. I'm not sure about cows' eyes. I walk on, and there is more, fresh poo – great explosions of sloppy dung, pock-marking the road like a war-zone. What if a cow was spooked by my sudden appearance in the dark? The road is hemmed in here by high cliffs, so there's not much room for evasive action. I don't fancy my chances against an irate mother, protective of her calf.

I reach a cattle grid and breathe a sigh of relief as my trolley-wheels rattle over it. Silly, really, to be scared of cows. I stop for a breather and shine my torch down the road. But what is that long, dark patch, still damp? Could it be cow wee? And then further on, more manure mortar-fire, splattering the tarmac.

As I approach the coast I sense the road widening and I can feel the wind on my face. At least here there's a possibility of escape, for me or the cows. However, I reach the shore unmolested. Maybe the beasts have gone to eat seaweed now the tide is out. Relieved, I settle down to wait for Mike.

Opposite:
stonechat.

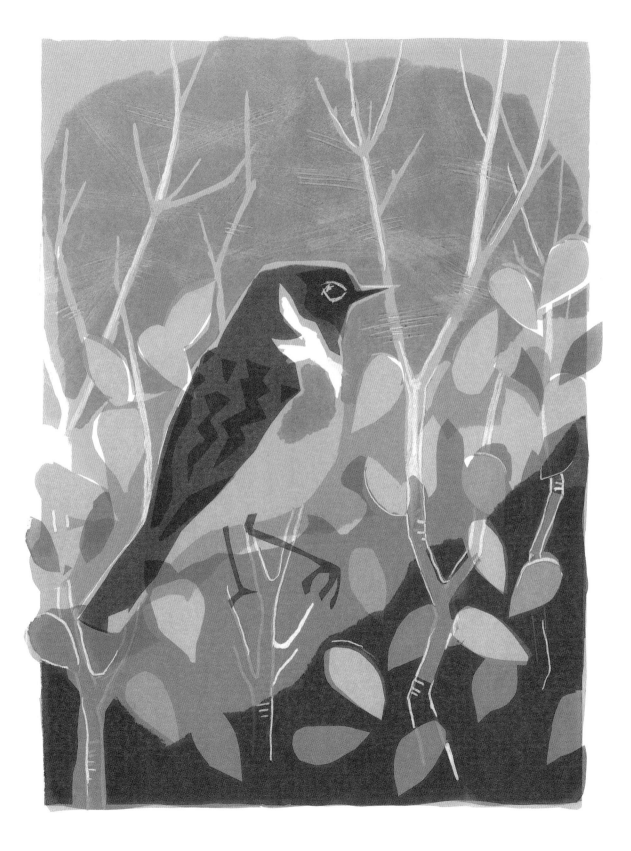

# Grey Seals

I have come here in October as now the grey seals are pupping. Mike shows me a place on the shore where I can drive the Land Rover close to their colony without disturbing them. In the summer, the smaller, prettier common seals bred on the sandy shallows of the Strand, but these greys are big and tough. They give birth now on the rocky shore, despite the autumn storms.

At first I find them impossible to draw. They look like enormous slugs, galumphing around the shore. Shapeless. I remind myself that they are mammals with the same number of arm and leg bones as me, but in different proportions. They're like humans in sleeping bags. I imagine a skeleton hidden under all that blubber, and it helps.

By spending so many hours with them, I slowly get to know them. The seal pups are white and fluffy. They do not swim for their first month. Their mothers suckle them during this time, until the pups have trebled in weight and the females are visibly thinner. There's something very familiar about them all. There are many folk stories of seal people, selkies, who cast their seal form aside to live amongst men, but always pine for the sea. I watch the animals as their ungainly shuffle takes them into the surf, and they transform into elegant swimmers, gliding through the waves. Seals can stay underwater for up to twenty minutes and often sleep bobbing at the surface with just their noses in the air.

Over a thousand pups are born here each year, which is one of the reasons why Oronsay is officially designated a Site of Special Scientific Interest. Some of these seals have been tagged and followed on their fishing trips. Unlike the common seals which fish close to shore, they swim as far as the edge of the continental shelf. Grey seals really are animals of the wild west coast.

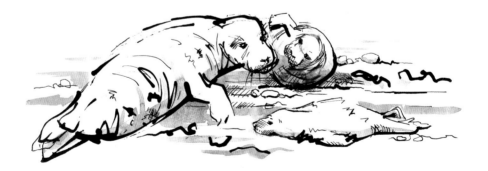

Opposite:

seal pup and starlings.

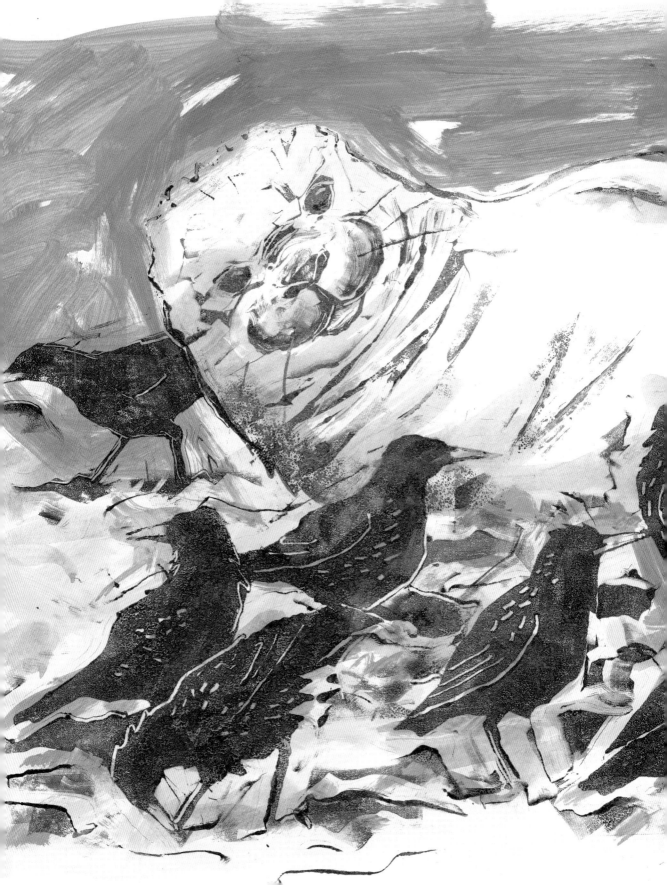

# Barnacle Geese Arrive

The monks of Oronsay's priory left behind carved images, but no written record of their lives. From other monasteries, natural history books called Bestiaries survive. In these, monks illustrated the life-cycle of the barnacle goose, which reappeared every year in autumn. Never having seen these birds nesting, they deduced that the geese hatched from goose barnacles, which wash ashore on driftwood in the autumn storms. With a long 'neck' (actually the mollusc's foot) and a goose-shaped grey 'head' (its shell), the barnacle does bear a passing resemblance to the goose, and they both still share each other's names. However the reality of the goose's year is even stranger than the monks surmised. Colour-rings have been attached to some of these west coast birds, and now we can understand the full story of their migration.

Oronsay's barnacle geese breed on cliffs in the high tundra of Greenland. When the Arctic days shorten, they fly south to Iceland, where rich volcanic soils and good agricultural land allow them to refuel on fresh grass. When the snows arrive there, they leave and fly non-stop to Oronsay, where two and a half thousand geese graze the fields in winter. West-coast winters are mild and wet and the grass can grow all year long.

When they returned I was on the mainland, but Izzy told me of skeins of geese stretching to the horizon. They arrived in flocks of fifty to a hundred birds, and in the space of thirty-six hours the island's goose population increased by a thousand. This is what she wrote in her email:

> By October there are fewer sounds of wildlife. The air isn't humming with bees, and birds are much less vocal. When the wind dies down it is so still except for the robin, trickling away. When the geese arrive, they are constantly bubbling and chattering to each other in the flocks. As they all burst into flight off a beach or field, their sound erupts and transforms the island. Every time they take off you can't help but stop what you are doing and stare in awe!
>
> The arrival of barnacle geese does alter the feel of the island. It signals a change and the coming of winter farmyard routines. It feels like a privilege that they come all the way from Greenland and Iceland to Oronsay and you can't help but wonder what they've seen.

You never know what other travellers you may find during the morning sheep-round. Pale-bellied brent geese arrive overnight. They've nested in Canada and have flown here over the top of the Greenland ice-cap. They're on their way to Strangford Lough in Northern Ireland, but may have been forced down by headwinds.

Small groups of Greenland white-fronted geese have also appeared. They are en route to Islay, but every year a flock of about one hundred will stay to overwinter here.

Family parties of whooper swans sleep after their journey. Their long necks are looped back, beaks tucked into the warm air under their feathers. Two days ago they were feeding on aquatic plants in Iceland, and their necks are still stained orange from the peaty loch water.

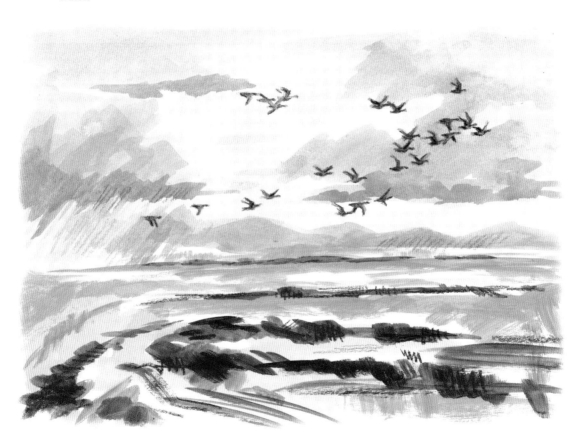

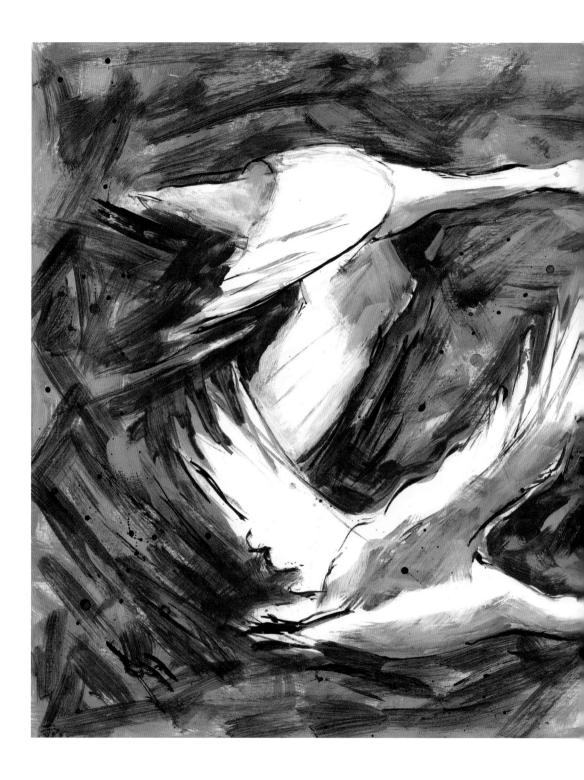

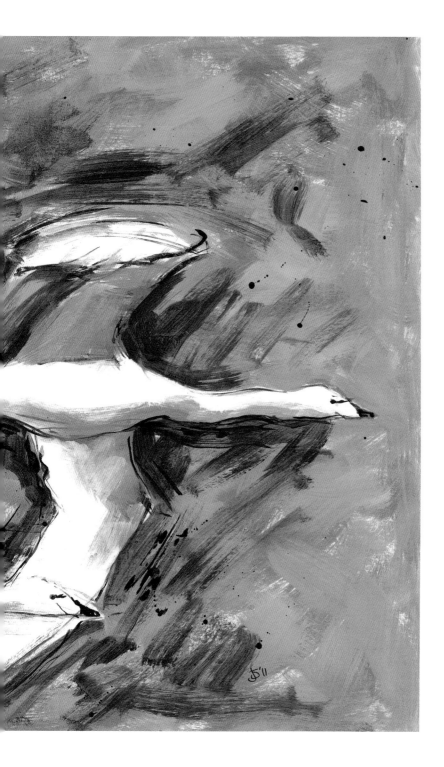

Whooper swans.

Barnacle geese.

# NOVEMBER
## *A Mad Rush*

My husband, Mark, has just come back from filming *Autumnwatch* and has a week at home before the next filming trip, so I grab my chance for a trip to Oronsay. The children grumble. 'You can't leave us with Dad. He forgets to give us a snack for break-time.'

'Well, you'll have to remember to pack it yourselves, then.'

The kids leave for school with PE kits, packed lunches and all. Mark has a film crew from the BBC coming to film at the house for a series about Scottish wildlife cameramen. We run around scooping children's pyjamas off the living-room floor and wonder whether it's necessary to see the view from the windows. At present it's obscured by a smear of small sticky fingerprints. And the bathroom needs cleaning. Luckily I sorted out my paints last night. Pack in haste and repent at leisure otherwise.

I only just make it to the ferry. There's hardly anyone else on the ship, just a group of undertakers in black ties. There's a hearse on the car deck with a tiny coffin. Someone tells me it's a lady who had to leave Colonsay during her final illness, and is now coming home to be buried.

I chat with the ferry steward who is clearing the teacups, and he reminds me that it is November the fifth. Recently Oban made the national news when their whole firework display ran away with itself and exploded in a mad and spectacular 38-second rush.

The low November sun floods through the picture windows onto the benches and I lie down to bask in the unseasonal warmth. I wake to a crackle of walkie-talkies as the ferry makes a shuddering pirouette to come onto the Colonsay pier stern-first. I try not to be like the summer tourists who queue anxiously to get back to their cars. I wait for the announcement on the tannoy, but instead I hear two of the passengers who are watching the hearse that is being driven onto the island. Oh no! Wasn't I parked just behind it? I grab my bags and rush downstairs to see a disgruntled Land Rover blocked in by my car. That'll teach me. I'm still a tourist.

# Beachcombing

Val walks the dogs twice a day on the long sandy beach that faces west to the Atlantic. This also gives her the chance to see what new treasures the sea has washed up. She has found sea beans, of which we are all envious. They are vine seeds, carried all the way from the Caribbean, and here in the Hebrides they're considered lucky charms.

Once a log covered in goose barnacles came ashore. They were still alive, all sticking out their necks,' Val told me. 'I fetched the others to see it, and we tried to refloat it, but without success. The shorebirds had a feast, and afterwards we had the wood for the stove.'

In some coves, pieces of blue pottery are still washed ashore from a boat that was wrecked in 1881. Tantalising fragments of blue-painted scenes are clearly visible, but the sections rarely join together. The finder is left to guess the rest of the picture.

The best find was a message in a bottle, found on a beach-clean. It had been tied to a helium balloon in Newfoundland by author Ross Traverse, wishing to publicise his book, and it offered a $100 reward to the finder. The bottle had fallen into the sea and washed ashore on Oronsay three thousand kilometres away and five months later. Ross's wife bought him a plane ticket for his birthday so that he could visit Mike and Val. He increased the reward and donated it to local wildlife charities.

Barnacle goose.

# Trying to Draw Barnacle Geese

Although the geese have been here a few weeks, they are still nervous and flighty. I can drive the Land Rover into the field next to where they are grazing, but if I stop the engine all their heads go up to stare at me. They walk slowly away, but if I move, the whole flock launches into the air.

Normally my pictures are sparked off by some colour or pattern that links the subject to its surroundings. A bird's plumage often has a visual link with its environment, I suppose as a camouflage. But here, the geese look as out of place as a herd of zebra on the island fields. I can see why their markings confuse predators. It's almost impossible to pick out individuals, and I just can't find a way of portraying them. At the end of a cold and frustrating day I return to the farmhouse, where Val consoles me with a gin and tonic.

The fields around the house were mown for silage after the corncrakes had fledged. Now there's fresh grass growing here – the richest grazing on the island. From the kitchen table I can see a speckled black and white flock alight at the field-end. Farm work has finished for the day and the tractors and Land Rovers are parked in the yard. Mike is watching rugby on Sky Sports and the girls have gone home. I fetch my binoculars and pens, and sip my gin as the geese graze their way towards the house. As they come closer, I can appreciate the delicate patterning of individual birds, and work out how the feathers lie. The black markings curve around their bodies, following the contours and emphasising their roundness. Every time they move, a different set of curves presents itself. The black and white must give camouflage amid the snow and rock of their nesting grounds, against predators such as Arctic foxes or gyrfalcons. We often think of geese as domestic animals, but these now seem to me more exotic – creatures of the dry, bright, cold tundra, so different from this soft, damp, green dusk of Oronsay.

I draw as much as I can, until it's too dark to see. I'd forgotten that it's not always necessary to be uncomfortable to get great views of wildlife. After dinner I go to bed and listen to a thousand Arctic voices outside the window, telling tales of the tundra.

Next page: barnacle geese.

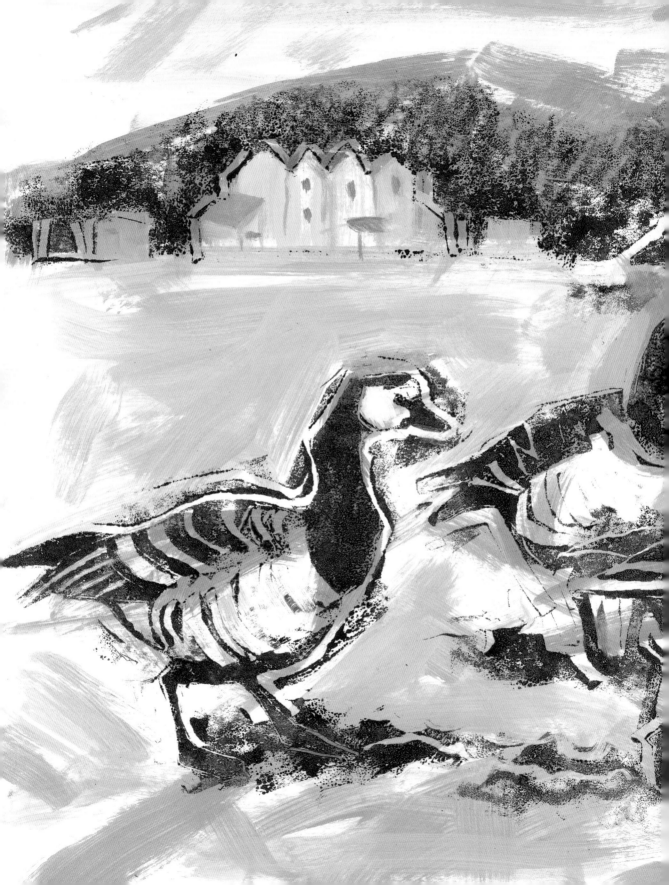

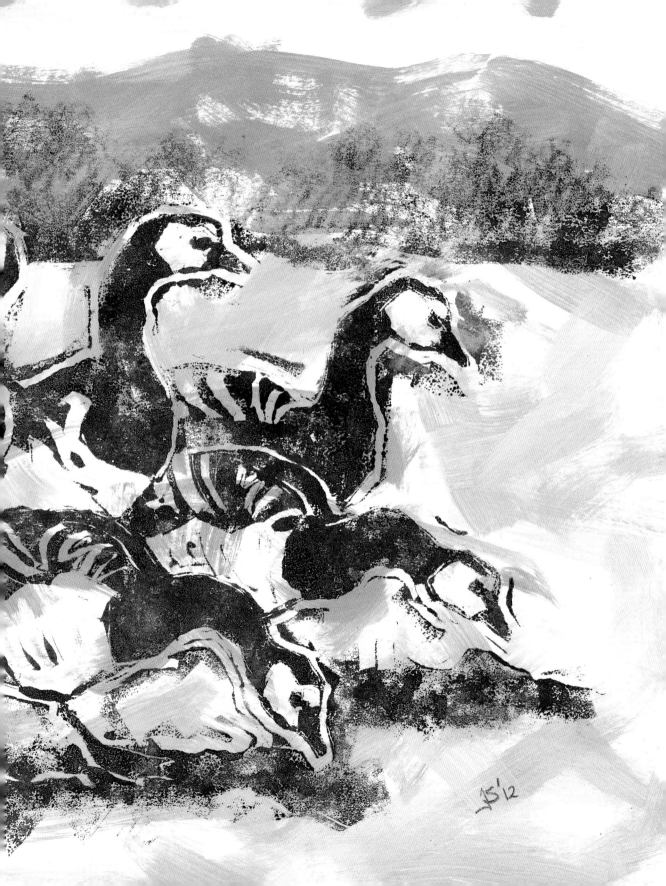

# Printmaking

My work always starts with a real-life experience, an encounter with bird, animal or land-scape. I want to share those snatched glimpses of wild behaviour that usually come only from hours spent out of doors. I try to grab some record of that moment – maybe a pencil scribble on a chocolate wrapper from my pocket, or if I'm lucky, a proper field sketch with paint and crayon.

Real life is so overwhelming in its complexity that it's not possible to convey everything one sees. The sketch is a translation, a distillation of experience in the same way that a poem condenses ideas. These sketches can sometimes stand alone, but often they are so scribbly that they are hard for others to interpret. Crucially, though, they reveal the energy and excitement of the moment, and that is what I try to hold on to at the next stage.

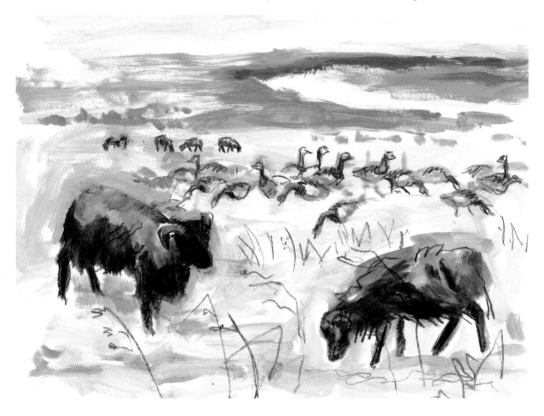

In my studio at home I can make a more considered piece of work about the encounter. I work from my original sketches and use printmaking to simplify the ideas even further. Over the years I've experimented with many types of printmaking. They all involve building up layers of ink, and provide a great way to experiment with colours, shapes, tones and textures, by manipulating them all separately.

In a mono print (like the previous double-page of barnacle geese), the energy in the picture comes from the texture of the ink, which I roll out onto a glass plate and then press directly onto the paper.

With screen printing (as above, and inspired by the field sketch, opposite), the energy comes from the thin overlapping layers of colour that combine to make new colours.

Printmaking is also a way of relinquishing a little control over the final image. I never quite know what the picture will look like until I peel back the paper.

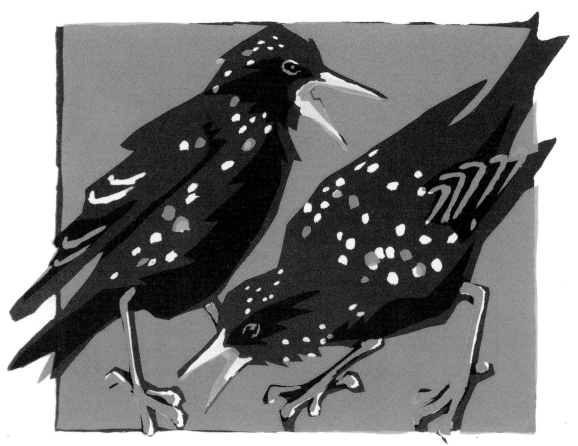

Starlings.

# DECEMBER
## *Where Am I Going?*

As I step onto the dark pier, the Colonsay drizzle blowing in my face is refreshing after the stuffiness of the ferry. This time the film playing in my head is an old black and white one, *I Know Where I'm Going*, in which the heroine is trying to cross to the fictitious Hebridean island of Kiloran, in bad weather. Things do not go well for her. The film has a MacNeil laird, some eccentric local characters, and a curse. Best not to dwell on it, I tell myself.

Several vehicles are silhouetted against the lights of the shop. Mike had told me, 'Just use Duncan and Margaret's Land Rover. It's parked outside the Post Office and the keys are in it.' I choose the biggest car and try the door. What if someone's sitting inside? Or comes out of the shop to find me nicking their motor?

I heave my bags into the back and climb into the driver's seat, giggling. The car has the familiar West-coast smell of roll-ups. I turn the key and Argyll FM starts up with the engine. Classics Night. As I drive cautiously up the road in my Trojan Horse, islanders wave at the car. I feel like a local, which is the ultimate fantasy of any regular visitor to Colonsay. I have a few hours to wait for the tide, so I stop at the pub.

Everyone in the bar turns around when I walk in. They're not fooled. I get a drink and sit in the corner. A wee boy is sitting with the older men, playing with his dad's phone.

'What's your number?' he asks the barman.

'I don't have a mobile,' replies the man, 'I just shout.'

On an island this small, that almost makes sense.

The walls of the bar are covered with sepia photos of former locals; crofting bairns with shawls and bare feet; a milk-cow; the Edwardian funeral procession to Oronsay of a laird, John MacNeil.

I finish my drink and drive to the Strand to wait for Mike. It's pitch-black and I would never find my way on my own. Rain drums on the roof and the sweeping orchestral music on Argyll FM provides a dramatic sound-track. On the horizon a beam like a lighthouse appears then disappears behind the hills. As the violins start to build a theme, the light re-appears, now as two headlights. In the 1945 film, the heroine's boat is caught in a storm and gets sucked into the Corryvreckan whirlpool. The hero comes to her rescue but she never

makes it to the island. I wait anxiously. The music swells as the horn section picks up the orchestral refrain. Over the next five minutes, two lights gradually become four as the head-lights reflect on the wet sand. Eventually the Land Rover appears out of the darkness. Thank goodness Mike knows where he's going.

# Starlings

After a day of battling against the elements on Oronsay, I seek shelter in the barn to make use of the last hours of daylight. The building is high and airy with slats at one end. These slats interrupt the gale and moderate it to a sigh, giving volume to the space. It's a place of calm, a pleasant refuge. The chickens seem to think so too. A hen clucks quietly as she picks through the hay for seeds, followed by her cheeping brood. Rock doves croon in the rafters above. A brief rain shower patters on the roof and then, after a minute, there's a gurgling as water flows in the down-pipes.

Through the slats I can see the light of pink clouds, and then a swirl of silhouettes as a flock of starlings banks across the vertical lines; a live action zoetrope. Dark shapes flutter like ghostlets through a storm-ripped hole in the barn roof. The birds alight on the girders, preen, and then start to run through their repertoire, *sotto voce*. It's the males that sing; a rambling melody of warbling, whistling and clicking, together with impersonations of all their Oronsay neighbours. I am treated to a performance of all the sounds of the Hebrides in winter. The bubble of a distant curlew. The rhythmic craking of a snipe. The cheep of house sparrows and alarm of a blackbird. The mew of a buzzard. Jackdaws. Wait a minute. There are no jackdaws on Oronsay, but they do nest on Colonsay. I wonder if this mimicry tells other birds where the singer has been foraging.

Through the Perspex roof lights I see another flock swirling above the barn. This feels like sitting on the ocean floor below a shoal of fish, with the roar of their wings like waves on a beach. More starlings flood in, and the tops of the roof-beams are soon occupied, the birds wedged in under the roof, a pecking distance apart. Any who try to disrupt the equal spacing get ousted with a few jabs. Next, the narrower side-ledges of the girders fill up. I look on the floor below and realise that there are strips of bird droppings corresponding with the beams above, as well as a few feathered remains. Mike says a sparrowhawk was hunting in here recently. The starlings abandoned their roost for a week, but this place is so perfect for them that they soon returned.

Yet more birds pour in through the roof, and the noise rises to a crescendo. At this time of year, youngsters make up a large proportion of the flock. Both their dress and their singing are less refined than the adults. They are moulting out of their drab baby plumage, and are screeching, screaming and jostling. It sounds like a conversation between a flock of swifts and a tribe of clicking Xhosa warriors. The noise is extreme down here. Up there you'd think it would be deafening. Latecomers try to barge in, so there's much flapping and pecking, squawking and fluttering.

The chickens fly up to roost on ledges in the wall with a heavy whirring of wings. They preen and settle down to doze, but still the cacophony continues. The rock doves fall silent too, but not the starlings. The adults have recently moulted into iridescent fresh plumage with white-tipped body feathers. They remind me of sequin-spangled partygoers. The noise gradually subsides, but then other birds take advantage of the lull to show off their own party-pieces, and away we go again. At a sleep-over there's always one who doesn't want the fun to end when the lights are turned off. Just as human sleep-overs are about socialising as well as snoozing, roosting is also about reconnaissance as well as rest. Research has shown that in some way birds are exchanging information – about feeding locations and about each other.

Gradually there's more singing and less screeching. The shapes against the windows become spiky, headless balls as the starlings tuck their beaks back under their feathers and sleep.

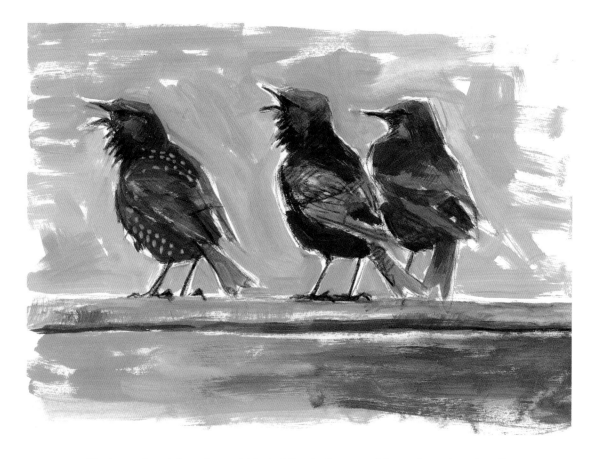

Next morning at dawn I go outside, but the starlings aren't in any hurry to get up. Some are awake and preening, but others – maybe those that were carousing late into the night – still have their heads under their feathers. I wait in the yard for them to emerge. A few brave individuals hop out onto the roof, but then dive back in. When a group of twenty are gathered, they launch out, but not in a tight flock. They dive and whiffle and jink, down to the ground like autumn leaves tumbling in the wind, then skimming the shed roofs, they gather warily on the chimney-pots and slates of the house. The sparrowhawk has spent the night in the withy of low trees behind the farmyard, and he'll be ready for his breakfast.

# Rats

Last winter Mike decided to try and clear rats from Ghaiodeamal (pronounced *Gerchmol*). This is an islet half a mile to the east of Oronsay, where Arctic terns used to breed in summer. Since Mike has been here, not a single juvenile has fledged. There are plenty of wrecks around the shore, and the rats must have invaded when leaving the sinking ships. With autumn-breeding seals and summer seabirds, the rats had a year-round gourmet supply of food, and were thriving. They tunnelled into the peaty ground and destroyed the vegetation as they dug up bulbs and roots to eat during the winter.

Once, these offshore islets were rare, safe nesting places for birds, and Mike wanted to repair the damage. An ecologist was contracted to undertake the project, laying poison bait in tubes only accessible to the rats.

This winter we want to know if the eradication programme has been successful. The water between Ghaiodeamal and Oronsay is fast-flowing and cold, so the rats probably won't repopulate.

Once the seal-breeding season is over we wait for a calm day and cross to the islet in Mike's boat. We have the delightful task of removing any dead seal carcasses, so depriving the rats of alternative food, and then we lay down monitoring blocks of wax, cocoa and peanut butter. If, in a month, the blocks have not been gnawed, then the project can be declared successful. Not only Arctic terns, but also storm petrels and corncrake will benefit. We are all excited to see if the terns will raise young next summer.

# The New Bulls

Daylight is in short supply in December. We're up before seven, as work in the yard starts at eight. In the half-light I can see the new bulls waiting for their breakfast by the fence outside the kitchen window. I prop my sketchbook up on the counter and paint while I eat my muesli.

The newcomers have been given the Gaelic names of *Niata* (Courage) and *Neart* (Powerful), but are known as Curly and Wurly. They were only eighteen months old when they arrived, and Mike wasn't sure if they'd even be tall enough to do their work. They were each given a group of cows, but the old bulls were kept on for a season, just in case. All four males performed successfully, with Eriskay proving he still had plenty of life in him. Mike saw him gallop at the six-foot stone wall and clear it like a show-jumper in order to reach the youngsters' females on the other side. Despite this, Eriskay and Expectation had to leave Oronsay in the autumn to avoid in-breeding. After seven years of siring calves, all the breeding females are their daughters or granddaughters.

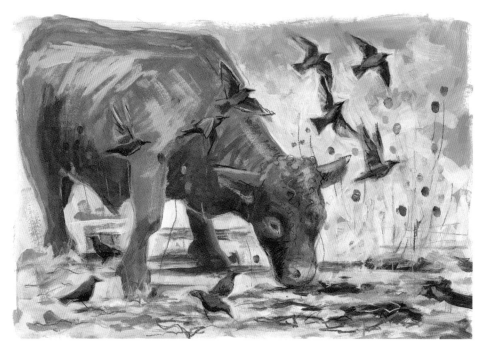

Bull and starlings.

# A Christmas Adventure

On Christmas Eve some years ago, a group from Oronsay crossed the Strand for the midnight carol service on Colonsay. Val, being the most responsible member of the party, did not partake of the hotel's hospitality afterwards, and so was the designated driver. When the revellers set off across the Strand in the wee small hours, it was pitch black with a roaring gale and horizontal rain.

'We couldn't see a thing,' remembers Val. 'Everyone was offering their opinion on which direction we should take. Arms were pointing everywhere. And then, suddenly, we just came to a halt.'

Luckily, Mike had considered it his moral duty to look after the fire at home and to keep the TV warm for their return. He still remembers the phone-call.

'I could hear a little voice on the other end, above the roar of the gale, crying "Help! We're lost. We don't know where we are and the tide's coming in!"'

He took the tractor down and found them, not on the track, but way out towards the sea. They worked in the pouring rain to pull the Land Rover out, reaching home at three in the morning.

Their first job on Boxing Day was to put out more reflectors along the route, for headlights to pick out on a night crossing.

Curlew.

Heron.

# *A Rough Crossing to Colonsay*

'Only four jam jars and a van today,' announces the CalMac steward.

The boat is certainly empty. In the cafeteria a granny berates a young lad, who hangs his head while his friends all giggle behind him. This would be unremarkable, except that the boy is a member of the catering staff. The lady must be from the island, as they all seem to know each other and everyone is laughing and joking.

As the boat comes out into the open sea, I go upstairs to lie down. It's the roughest crossing I've experienced so far, and this is when the captain decides to do an emergency drill. He explains this over the tannoy in an avuncular voice, but I'm not very reassured. Fortunately the passengers aren't required to take part, so I lie still and concentrate on keeping my stomach together.

'All crew to upgrade to general emergency.'

I wonder why ferries have carpets on the floor. With a regular potential for vomit landing on them, you'd think they'd get something that was easier to clean.

'All crew proceed to abandon ship stage one.'

The boat shudders as the bow plunges into a wave.

I'm always happiest on solid land. We have a small sailing-boat, but it really belongs to Mark. I prefer to get out and walk. I remember filming on a boat in the South Atlantic and being so sick that I though I was going to die. I would happily have tipped myself over the railings into the sea.

'All crew to abandon ship, stage two.'

Well, it's my fault for choosing a project on an island. There's plenty of wildlife nearer to home.

Eventually the captain informs us that the exercise is over and any further announcements will be the real thing. I'm glad to trundle my bag of paint and food down the gangway and get my feet onto the Colonsay jetty.

# Feeding the Cattle

Next morning we head out at dawn to feed cattle. It would be much easier to keep the animals indoors in the winter, but by feeding them outside in the traditional way, the wildlife benefits too.

'When it snowed last winter,' Mike tells me, 'there was a flock of fifty skylarks feeding on the seeds from the silage.' The cattle poach up the ground, knocking back bracken and introducing wildflower seed into the earth.

When Mike first came here he put the silage out from a trailer.

'It was very hard work. Every day I would fork out two huge bales. But it was a good way to get to know the individual animals, and I got incredibly fit.' Now, though, the tractor tows a bale-shredder. The spinning knives inside it chop and bruise the silage, making the food easier to digest. Mike supervises Nat and Izzy until they're confident with the new machinery. As he says, 'If you stuck your arm in there, there wouldn't be much left of it.'

I stay on to draw the starlings, which are feeding around the feet of the cattle. The others go back to the farm, but after a while I hear an engine returning. It's the two girls in the Kubota buggy. The bale-shredder has a puncture and is blocking the road.

'Mike is swearing,' says Izzy, 'a lot! So we're heading back the long way round to fetch the spare. If we can't fix the tyre, it's back to forking silage by hand.'

Opposite:

Cows and starlings.

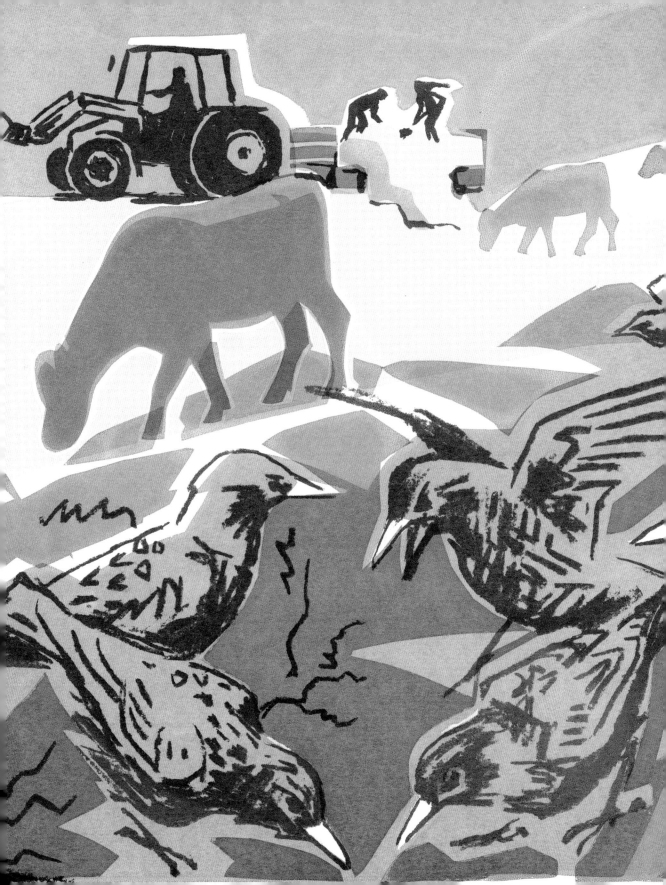

# Storms

The TV news is threatening a 'weather bomb', as the air pressure has dropped by 24 mbars since yesterday. Stornoway Coastguard has warned that the sea state could become 'phenomenal'. All ferry sailings on the west coast have been cancelled.

Winter is a tough time on an island so exposed to the west. There is nothing between Oronsay and Newfoundland except three thousand kilometres of Atlantic Ocean. There are no trees here to break the force of the wind. The work must still be done, and everyone has their hoods up and their heads down. Battling against the wind is exhausting. We are hoping there won't be a power cut, or we'll be completely isolated: no mobile, no telephone or internet, no heater to dry wet clothes, no hot water, no cooker or TV. We could radio the coastguard in an emergency, but only if the relay on Islay was working.

It's hard to sleep in the upstairs room. Tiles are clattering above me, windows are rattling in their frames, wind roars in the chimneys and the whole house is shaking. It sounds as if the roof might lift off.

Next morning the air is full of salt spray. 'Oh my God, it's like Armageddon,' says Mike. Outside the back door, roof slates are on the path and a dead starling lies outside the barn, still warm. It must have been caught in a downdraught and smashed to the ground. We dare not use the Kubota with its large doors, as the wind would rip them off their hinges, so we all cram into the Land Rover and drive to the South End. The gulls have fled the wild sea and are sheltering on the fields, bills pointing to wind like a flock of weathervanes. Barnacle geese spread their wings and shoot skywards, flying forwards but travelling backwards. Waves like moving mountains sweep up the coast. Hundreds of tonnes of water rear up in a churning blizzard of foam, spray ripped from the crests by the gale.

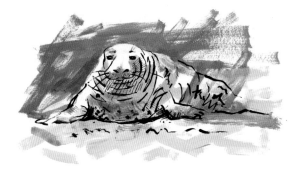

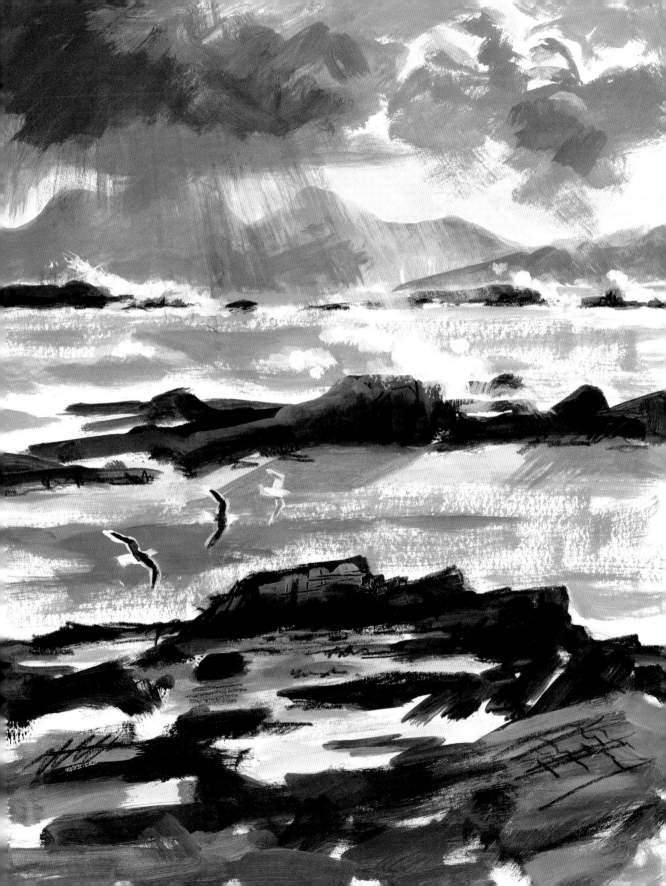

# Field Sketching

The storms have washed great piles of kelp onto the beaches, and after a week, kelp fly maggots are starting to hatch. Using the Land Rover as a hide, I go to look for feeding choughs. Many of the birds are colour-ringed so their behaviour can be studied. There is one resident pair on Oronsay, which breeds every year in a cave on the mountain. Choughs first breed at three or four years old, if a territory is available, and if they are successful, the couple will stay together for life.

In winter the Oronsay pair roost in a hole in the abbey ruins. Last year Mike saw the pair flying back at dusk in a storm. The female was caught in a downdraught and hit a stone wall. He last saw her sheltering from the wind as night came on. Ten days later the male was seen alone.

This summer the male took a new mate, but all the chicks were born blind and failed to fledge. Mike took feathers from the nest site to have their DNA analysed. We are all waiting anxiously to see what will happen next May.

Adolescent choughs band together and often visit the Oronsay shoreline in winter. As I drive between the different beaches I put the heater full blast onto my feet to restore my circulation. When I find the birds I clip the telescope to the open window, and paint with the paper propped against the steering-wheel. It's cramped and uncomfortable, which makes me work fast, and gives some energy to the field sketches. If I'm not careful, though, this energy can be transferred to the dashboard of the car, and so I keep a damp rag handy to remove errant daubs. On the passenger seat I have a box of crayons, a bundle of brushes and a box of acrylic paint. My palette is a copy of the *Radio Times*. It is shiny enough to use as a mixing surface, but absorbent enough to soak up paint when I turn the page for a fresh palette. It also provides entertainment while waiting for the rain to stop or for a bird to appear.

# Leaving Oronsay

I get up in the dark, listening to rain being flung at the windows. The ferry should be running again after the storms and I plan to return to the mainland today. I will take the wheel of the bale-shredder with me to be fixed in Oban. I must cross the Strand to Colonsay at low tide, which will be at 7am. A crescent moon is high in the sky, so the tide should drop enough to expose the sand, but when there is low air pressure and wind from the south, the tides can be smaller.

As we crest the hill and see the Strand below in the half-light, it is an expanse of sea. Mike is already making alternative plans. 'We could canoe you across but it's very windy, and I wouldn't get that wheel fixed. Let's go and look at the old pier. The rule is that if you can keep two wheels dry when you skirt the pier, the Strand is passable.'

There is just a car's width between water and stone and so, cheering, we drive into the sea. It's surreal, and I'm glad Mike is at the wheel, as my confidence would be wavering just now. 'This is why we have to get the Land Rovers serviced every three months,' says Mike. 'And I'll have to give the brakes a pressure-wash when I get back, to get the salt off.' We have a bow wave and a wake! It feels like we are in a boat, but our wheels stay on the sand and we reach the far shore safely.

Choughs.

# A Coast Rich in History

I have time for a quick visit to the island before half-term. As the ferry glides south towards Colonsay on calm, steel-grey waters, the shore is lit bronze and gold in the low winter sun. I am reminded of the ancient people who left their treasure here buried in cairns and graves. At this time of year, when the land is sleeping, it is easier to feel a connection with the past.

Mark and I have kayaked this coast, although not in a boat of wicker and hide as the ancients did. By travelling in the same way we found ourselves using the same features of the landscape: camping near burns for fresh water, and searching out sheltered beaches where a boat could be hauled out. This coast has never been intensively farmed, and many layers of history still remain near the soil surface. It is still possible here to find chips of flint on the shore, discarded thousands of years ago from the making of tools.

We slip past the Garvellachs or Garbh Eileaichs, the Rough Isles, although today they're becalmed. One and a half thousand years ago, Saint Columba is thought to have stopped here, and Eileach an Naoimh, the Holy Isle, is said to be the burial site of his mother, Eithne.

A thousand years ago this region became known as Earra Ghaidheal (mutating to Argyll), the Coast of the Gaels. The Gaels were a seafaring people who held power between Ireland and Scotland. The Hebrides became known as Innse Gall, the islands of the foreigners or Vikings. At the end of the twelfth century the Viking leader, Magnus Barefoot, agreed a treaty with the Scottish king giving him control of all the Scottish islands that he could travel around by boat. He managed to include the Kintyre peninsula in the deal when he stood at the helm of his longboat as his men hauled him on rollers across the narrow isthmus at Tarbert.

As we pass the massive lump of implacable rock that is Scarba and the jumble of islets fixed in its wake, Colonsay appears on the horizon. I head down to the canteen for a cup of tea and am grateful that my journey to Oronsay does not involve paddling with freezing fingers, or being soaked in salt spray.

# The Farmyard

Winter seems to have been going on for ever. The fields are muddy, without much new grass, and there is standing water in the sand dunes. The calves have been in the shed since December to keep them out of the worst weather, but now it's the turn of the two bulls to come in for some shelter.

Mike tells me of the old bull Eriskay who was lying in the yard, waiting for the barn to be mucked out. When it was time for him to go back in, he would not get up. 'When I eventually got him to his feet, he was so fed up with me, he chased me three times around the tractor. Bulls are quite nimble, but they don't have a great turning-circle. You have to have something to run around if you're going to escape.'

The rain drives the hens into the barn and they perch on the railings until one of the bulls snorts at them, ruffling their feathers and sending them squawking to the ground.

Duncan McDougall, who grew up on Colonsay, told me about the local pre-wedding hen parties from years ago. Anyone who had a spare hen would bring it along to prepare for the marriage breakfast. Everyone would pluck the birds, and throw the feathers over the bride and groom. 'Of course it was very dangerous,' said Duncan in his lilting Hebridean accent. 'You can imagine the feathers from ten or twelve chickens filling the air. My sister almost choked to death before her wedding.'

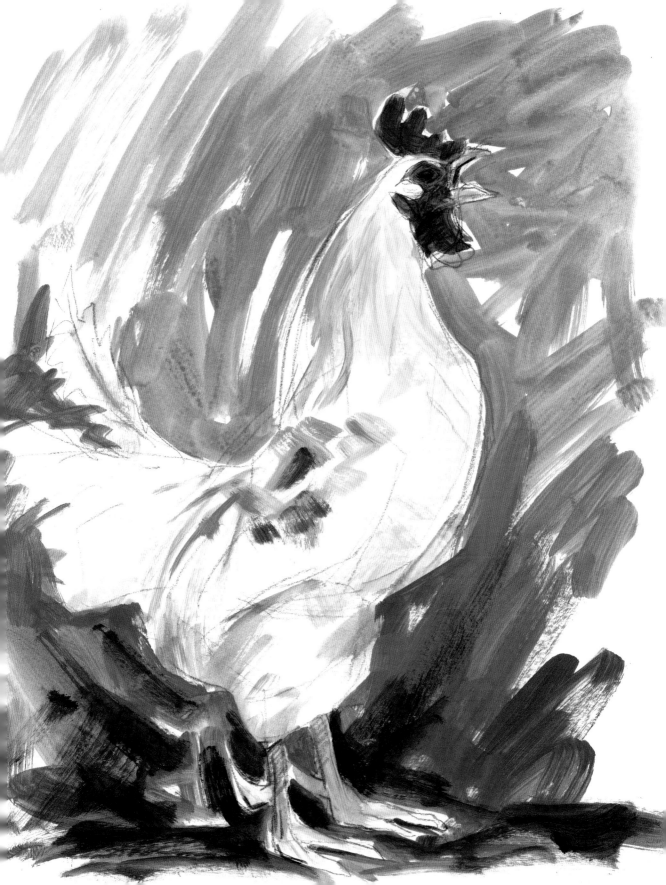

# Sparrows

From the shelter of the barn I can hear the constant cheeping of sparrows, a comforting and familiar sound from my childhood, but now rare on the mainland. Here, they hang around the yard, hiding in the rolls of spare fencing and waiting for the chickens to be fed, so they can scavenge grain.

Val keeps telling me to take a closer look at the sparrows, but there are always more glamorous birds to draw. Today, though, I'm sheltering from the weather, so I search them out. I soon realise what a mistake I'd made to write them off as 'just' sparrows.

Other birds that benefit from scavenged feed are the rock doves. The winter grass is bleached yellow now, and Mike puts out extra food for the cows.

Overleaf:
rock doves and cows.

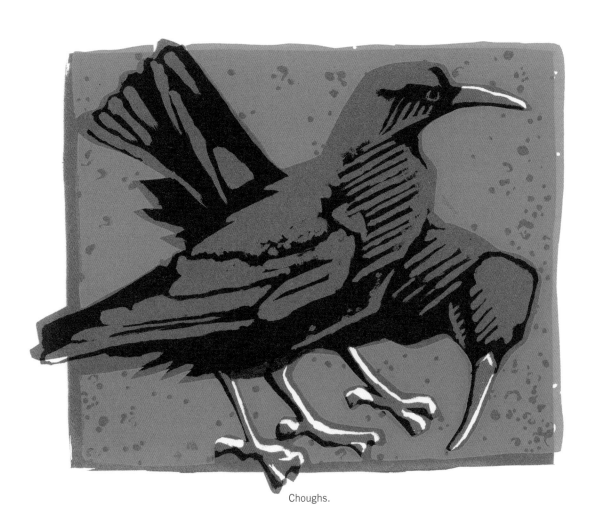
Choughs.

MARCH

# *Bees*

Mike has left me the Land Rover so I can drive across to Oronsay. On the Strand I meet Andrew Abrahams and offer him a lift. He is going to check his beehives on the island. Although the sun is shining today there's not much warmth in it yet. There won't be any flowers for the bees until willow catkins bloom in a few weeks. Andrew tells me that on an island like this there are a limited number of days every year when the air temperature is hot enough to make the nectar really flow. Warm days are also needed for the queen to fly high and mate with sufficient drones. She must store sperm to last her for 4 to 5 years.

'Last year was so cold and wet that one of my queens didn't mate properly, so I've got a replacement in my pocket.'

I take my eyes off the track. 'In your pocket?'

He takes a tiny mesh case out of his white bee-overalls, and crawling around inside is the new queen with her attendant bees.

They are native black honey bees, all but extinct on the mainland, yet protected here from disease and interbreeding by their island isolation. They are hardy enough to survive the west coast weather. Andrew has persuaded the Scottish Government to designate Colonsay and Oronsay a reserve for this bee, so ensuring its protection for the future.

# *Weather*

It's a cold, blustery spring morning. The island is so flat that you can see the weather coming a long way off. The clouds billow up thousands of feet, and rain pours from their dark grey bellies. Seconds later a dazzling sun emerges, and the soaked ground glows ochre. Lapwings dash through the wild air, their reedy cries whipped away by the wind. The sea is green.

At mid-morning everyone stops work for coffee in the farmhouse kitchen. Coats are hung up to drip dry and there's a forest of muddy boots in the porch. It's a chance to plan the rest of the day, now that the cows have been fed and checked.

The bread machine whirrs in the corner and Val consults the well-thumbed tide-table, known as the Oronsay Bible. 'Not a day goes past without me checking it five times,' says Val. The weather forecast is also vital: in planning whether the Strand can be crossed, whether ferries will run and what farming activities can go ahead. Oronsay is so far west, the forecast can often be wrong, with 'weather' being sucked onto the higher ground of Jura and Mull. 'If you work in an office, you probably don't even know what the weather is doing,' says Val, 'but here it affects every aspect of our lives.'

Chough and turnstones.

# Grumpy Tups

I can hear eider ducks displaying on the sea, but to get to the beach, I have to negotiate several gates. Each one involves getting in and out of the Land Rover twice, and many involve wrestling with an idiosyncratic and cranky bolt. Worse still, the entire route can be surveyed from the kitchen window of the farm, so all my tribulations may be noted by Mike. The trickiest part of this obstacle course is the gate onto the dunes where, every morning, a reception committee of tups awaits me. All winter they have been fed pellets to supplement the winter grass, and they see no reason why that should stop now. As I open the gate they all surge forwards, jostling around the Land Rover and banging it with their horns. I manage to get past them, but now of course the sheep are on the wrong side of the gate. I run around them to herd them back through, but more animals stream into the field, bleating expectantly at me. Eventually I grab the plastic bag that covers my sketch pads and shake it at them. It sounds like food! They stream back through the gate as I double-back and swing the gate closed, hoping that Mike has finished his coffee and is busy elsewhere.

# Eider Ducks

I track down the eiders by listening for them. Their calls express camp amazement, but with a cooing tone to it – imagine doves doing a Kenneth Williams impersonation. It's an evocative sound, and for me, each year, it's the sign that spring has begun.

The males stand out with their black and white plumage, but I have to use the binoculars to pick out the females. Their brown feathers camouflage them when they are incubating eggs on land. Right now the ducks are pairing up, chasing around, diving, splashing and showing off. As the males call, they toss back their heads and rise out of the water, trying to impress the females.

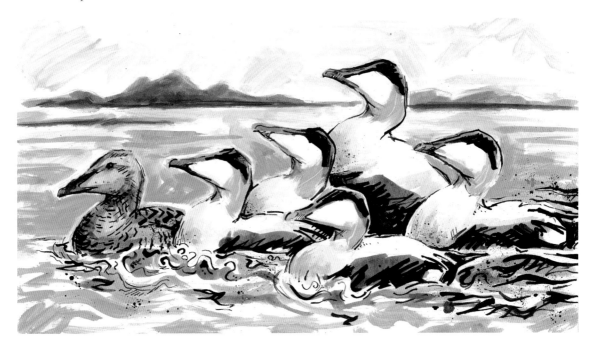

# Ringed Plovers

As I draw the eiders I am distracted by the urgent, insistent call of a smaller bird. I pick out three ringed plovers on the shore, camouflaged amongst the seaweed, but none of them are moving their bills. They are spread out strategically across the beach like mini masked marauders, but if this is a border skirmish, there should be a fourth bird. After twenty minutes of scanning I am beginning to think the plovers are ventriloquists. Every time I start to draw the noise begins again, but the tiny bandits continue their border patrol with beaks closed.

Eventually, almost under my nose, I spot it. The fourth bird is digging a nest scrape, chest on the ground and legs whirring, flinging out sand and pebbles behind him. And every time he does so, he calls frantically. As his mate approaches, he fans his tail and postures. The female looks unimpressed. With a flurry of piping the male goose-steps alongside her, in a style more military than marauding. As his calling reaches a crescendo he seems to convince himself, or maybe her, and flutters onto her back to mate.

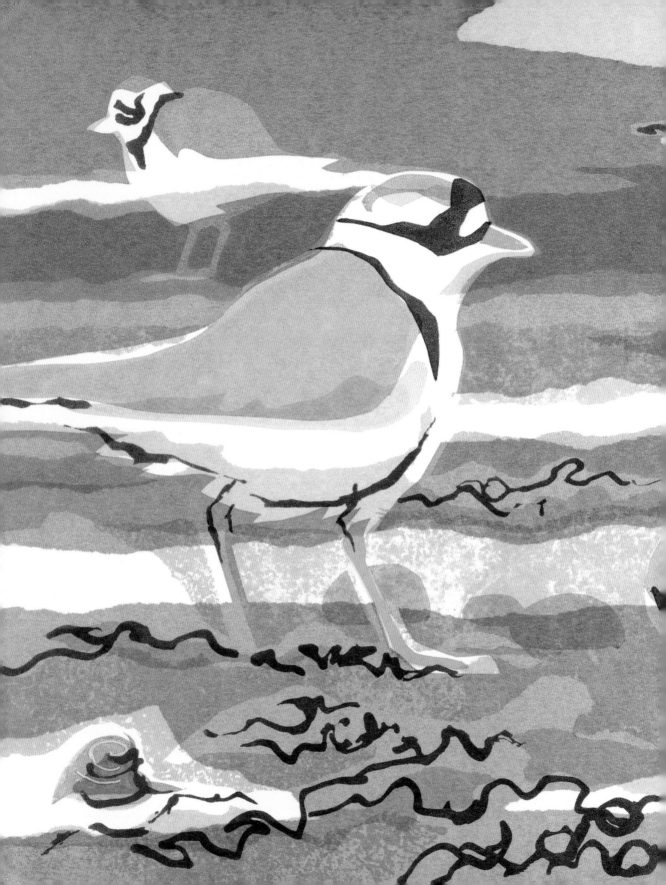

Ringed plovers
displaying.

# Too Much

Heeelp!! I've had to come indoors to save myself from this place.

It's as if the island is coming alive. At dawn I went out to draw the lapwings displaying. It was exhilarating watching their rollercoaster ride through the air, carving up the sky into loops and curves.

It's still cold. The wind was whistling through the holes in the floor of the Land Rover. After two paintings, I couldn't feel my feet, and I decided to head back for breakfast.

I didn't make it because I found the chough pair feeding in the sheep-field near the farm. They seemed like teenagers – hormonal and unable to settle to anything. A pied wagtail started hunting around the Land Rover and I got out my pens to sketch it. Before I could finish, I heard the choughs calling. They were right next to me, and as the female spread her wings, the male landed on top of her to mate. Wow! After a little preening, they flew off, leaving me scrabbling for my paints.

Out of the side window I glimpsed a pale gull with long white wings. An Iceland gull! I'd never seen one before, but there was no time to draw it. I had to get the choughs on paper. I ignored my freezing feet and got to work.

As I eventually packed up my paints, thinking of a hot cup of tea, the pied wagtail returned. No, no, NO! 'Go away!' I yelled at it. Enough is enough.

Now I'm back indoors, I've had to run up and down the stairs twenty times to get the circulation back into my feet. Luckily Mike and Val are not at home.

Pied wagtail.

Opposite:
two choughs.

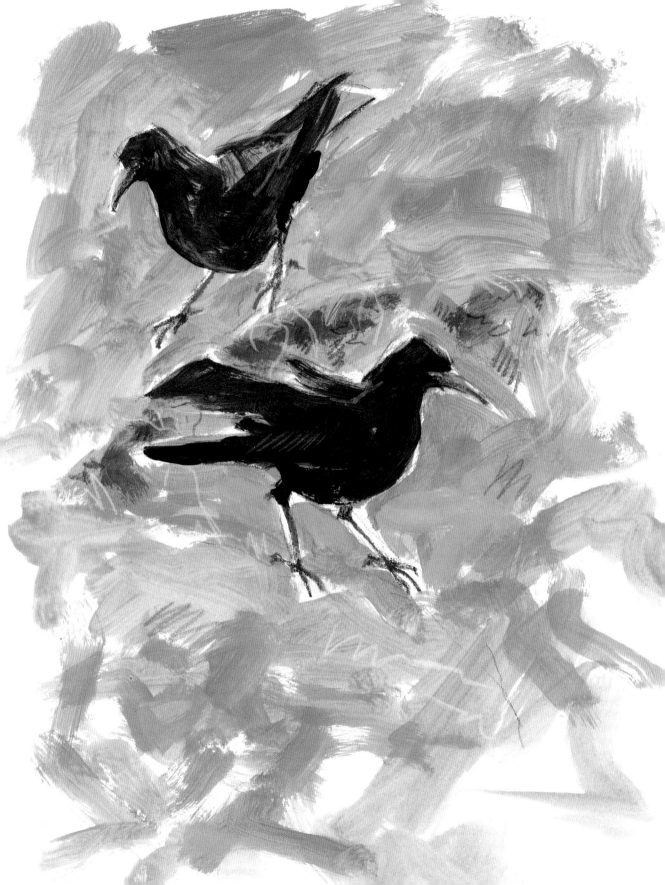

# Marsh Fritillaries

On the first warm sunny day of the year, we go to look for the caterpillars of the marsh fritillary butterfly. They feed on devil's bit scabious, a plant that grows in grazed, wet meadowlands. Across Europe many of these fields have been drained in the last fifty years and the butterfly is now rare.

On Oronsay cows have been put in to graze the marsh fields. Mike leaps about in the long grass, exclaiming delightedly at every new huddle of caterpillars that we find. They have over-wintered together in a silk web that protects them from frost. Even if the area floods they are kept safe here inside pockets of trapped air. Now they spin a new web on top of the plants and bask in the sun, their black bodies absorbing the heat and giving them enough energy to start digesting food. In this way they can survive the northern climate by getting going early in the season.

They look vulnerable out in the open like this, but their black spines protect them from bird predation. Their main enemy is much smaller than them; a tiny parasitic wasp. The story of this relationship is gruesomely fascinating. The wasp injects an egg inside the body of the caterpillar, where it hatches and starts eating the animal from the inside. The wasp grub spends all winter inside the caterpillar, and in spring bursts out, killing its host. The grub spins its own cocoon where it can change into an adult wasp, and so parasitise more caterpillars. As many as seventy wasp grubs can emerge from one caterpillar, and in some years they have a major effect on the butterfly population.

Caterpillars of the marsh fritillary.

# Noticing Things

On my way home, I disembark from the ferry in Oban and pack my binoculars away. I feel a bit of a nerd with them clunking around my neck. I already look weird enough with my paint-splattered coat. Waiting at the bus stop I notice that black guillemots (known locally as tysties), are pairing up in the bay. Everyone around me is busy, and no one has seen the birds circling out there on the water. I muse on the fact that there are advantages to being a birdwatcher, despite the nerdiness.

Birdwatchers notice things. That's the deal. If Mike said, 'Did you notice the buff-breasted sandpiper on the beach?' you'd feel pretty stupid if you'd missed such a rarity. So you keep your eyes open. You scan the horizon. Is that distant white shape holding its wings stiffly like a gannet or are they more flexible like a gull? Is that soaring bird a buzzard low down, or a more distant eagle? And those small dots at the end of the beach: are they just winter-plumage sanderling, or is one a buff-breasted sandpiper?

Artists also notice things; whether the sea is a green-blue or a blue-green; how to convey the broad bulk of an eider duck or the tent-shape of a rock dove's body; and the way those intricate markings on a corncrake help delineate its form. Luckily the other attribute needed by an artist is an ability to disengage the thinking part of the brain and let the mind float, in order to let different ideas connect. This, coupled with a fairly rubbish memory, has probably saved me from a life of overstimulation and mental exhaustion, leaving me free to enjoy twin pursuits that make even a wait at the bus-stop in Oban interesting. I decide that on my next Oronsay trip I should catch an earlier bus, and spend some time investigating the tysties.

Black guillemot.

Lapwings.

# APRIL
## *Tysties in Oban*

Oban is the place I go (reluctantly) to buy school shoes or get the car fixed. However this time I'm not in a rush and am happy to embrace the fun-fair atmosphere. The low rumble of ferry engines is overlaid with tinned bagpipe muzak from the tartan blanket shops. Seagulls call loudly from the rooftops. Hungrily, they eye the tourists who stroll along the promenade with fish and chips. Coaches disgorge pensioners in beige slacks outside the Pitlochry Knitwear shop. Other shops sell 'See You Jimmy' hats and souvenir Loch Ness Monsters. A street stall offers All Day BBQ'd Seafood. Brightly painted trawlers are moored three abreast at the pier, and the air is thick with the smell of diesel and shellfish. Oban is the Gateway to the Isles, the point of departure for the wild west of Scotland, and even the street pigeons have a cowboy swagger as they pick through the seaweed at low tide.

There is no sign of my quarry, the black guillemot, so I walk around to the north jetty. Cruise charter boats and an Ocean Youth Trust yacht are loading provisions. A board advertises Day Trips to the Seal Colony. I chat to the skipper who remembers when everyone came to Oban from the islands to collect their 'messages'. Now, he says, the big supermarkets have taken the heart out of the place and transplanted it to a massive car park on the edge of town.

Above the plastic shop-fronts I notice elegant older buildings. The Victorian architecture of the Columba Hotel, with its granite turrets and sandstone façade, stands next to the Art Deco curves of the Regent Hotel. On the hillside, genteel homes sit among lawns and rhododendron bushes. In contrast, like a giant Lego collection, the pier of the Northern Lighthouse Board houses enormous shipping buoys and a huge crane to lift them. Above it all, the amphitheatre folly of McCaig's Tower looks down upon the bay.

I am about to give up on the tysties, when surreptitious use of my binoculars reveals a group of black and white birds hanging out below the esplanade. I join them, crouching down below the road, out of sight of traffic and pedestrians. They are confiding, swimming in pairs only a few metres away, dancing in circles around each other. There is a high-pitched squeaking, which at first I take to be car brakes on the road above, but soon realise is made by the birds as they court each other.

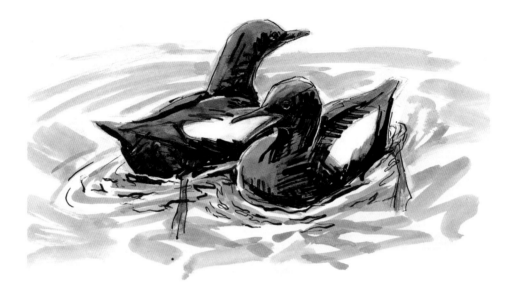

With a patter of bright scarlet feet, one bird takes off across the water. It does a turn around the bay to get up speed, the white of its wings flashing, and flies full tilt at the high esplanade wall. At the last minute it deploys its red feet as air brakes, and drops into one of the storm drains. Several surprised pedestrians stick their heads over the railings, and the tystie looks up at them from its nesting hole.

After a few sketches the stone ramp becomes uncomfortable and I retreat to a bench on the esplanade. A pair of tysties follows me right onto the pavement, so close that I have to stop using binoculars. They are as charismatic as starlings, but larger, and their feet and legs are impossibly red. When they snap at each other, the inside of their beak is also bright red. Some people walk right past them, while others stop and stare. It's as if a penguin is walking down the street.

The tysties perch a metre away on the edge of the sea wall. A woman stops right in front of me, gets out her mobile phone, and still they sit there. She takes a photo and then, as if they've won a dare, the birds flutter back down to the sea.

Beyond the birds, the massive bulk of a CalMac ferry is entering the bay. The voice of the Captain on the tannoy system drifts across the water. 'Ladies and Gentlemen, we are now arriving in Oban. Would all vehicle drivers please return to the car deck.' I pack up my paints. Ferry turnaround times are fast, and if I'm to catch it, I won't have long before it reloads and departs for Colonsay.

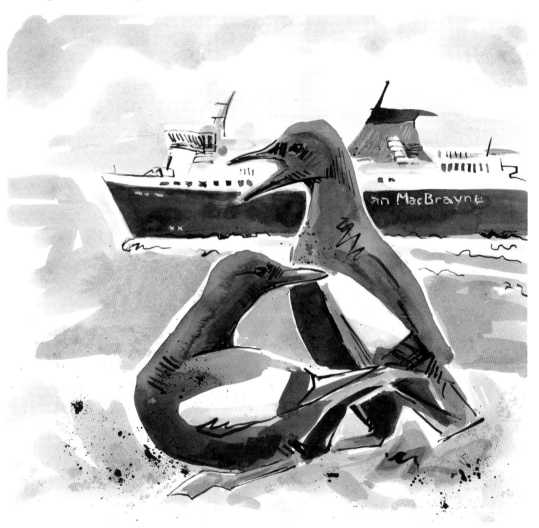

# Sheep and Lambing

Mike looks exhausted when he meets me with the Land Rover. I ask how he is. 'Buggered. Had to shoot a prolapsed ewe this morning.' Sheep are vital in making Oronsay a good place for wildlife and lambing season is an important, if stressful time of year.

Everyone is tired. The first lambing round must start at 5.30am as it gets light. Because the whole island is grazed, the sheep can give birth anywhere. If a lamb gets stuck on the way out, gulls or crows could come and peck at it, or even peck out the eyes of the exhausted mother. Other farmers might shoot the crows and gulls, but this is an RSPB farm. The staff must find any stricken sheep before the crows do. As with many of the tasks here, the wild-life-friendly way requires extra work.

If a sheep is found having problems with labour, it is taken back to the barn. A small flock of lost, rejected or orphaned lambs is also gathered there. If a lamb is born dead, the skin is removed and tied on to one of these orphans. The mother is fooled by the smell of her own lamb, and will foster the youngster. It's horrific and heart-warming in equal measure. Those orphaned lambs that cannot be adopted must be bottle-fed. This is a time-consuming and expensive job, but also great fun. They feed with such exuberance, nuzzling and butting and wriggling their tails.

All the usual work of the farm must be fitted in to the day: cows must be fed and dogs exercised, tractors mended, fences fixed, paperwork filled in . . . The day won't finish until 9pm when everyone has eaten and the washing up's been done.

Before I came to work here, all sheep looked the same to me. I could tell the difference between lambs and adults, but only when the lambs were young. Now, if someone told me to 'grab ahold of that texel tup', I could give it a go. Male sheep are called tups and females are ewes. A texel tup looks like a cross between a white gorilla and a pug – not pretty. By contrast, a Hebridean ewe has legs so long and elegant they might be clad in black stockings.

I also had to get to grips with the whole language of sheep ageing. A lamb becomes a hogg when taken from its mother. In its first year it's not put to the tup, so it just eats and grows. When it is first shorn it becomes a gimmer, or a shearling if it's male.

Gimmers are more likely to have problems lambing than experienced ewes, and are more likely to abandon a lamb, especially after a difficult labour.

This spring Val's midwifery skills have not been needed so much. She thinks it is because the winter was so cold and wet that the lambs didn't grow very big, and have popped out easily.

# Spring Migration

April is a time of change. Soon the geese will leave and the summer migrants will arrive. Mike has taken the cattle off the in-by fields around the house, to allow the nettles and other weeds to grow as shelter for when corncrakes return. The barnacle geese love the fresh new blades of grass on these ungrazed fields.

When we go out to check the animals last thing at night, there's a noise like a breaking wave as the flock takes off in the dark. Over the next few weeks the small flocks will join together and their calling grow louder and louder as they wait for a wind from the south. They must get their weather forecast right, as they make the first stage of their journey, to Iceland, in one flight.

Some friends recently filmed them on their nesting cliffs in Greenland. The footage, of tiny fluffy chicks parachuting off the cliff face to reach the feeding grounds below, was magical.

Oronsay's white-fronted geese will leave for Greenland at the same time, in smaller, family groups. I made a screen print of them feeding along the high-tide line among the seaweed.

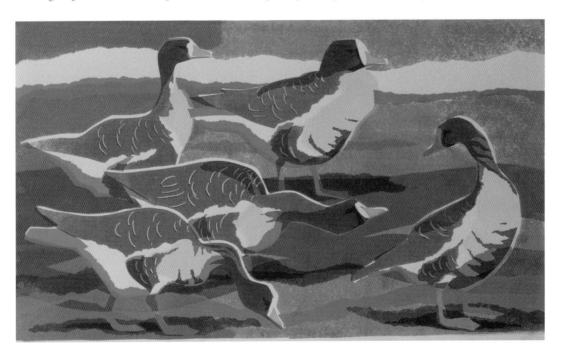

# Golden Plover

A flock of golden plover land near me. I lift my binoculars to look at them and, alarmed by my too-sudden movement, they all crouch to the ground, camouflaged perfectly among the hummocks of dry grass. Their beautiful, mournful calls accompany my sketching: the sound of a rusty-hinged gate blowing in the wind, the music of a vast open landscape. They too are bound for the uplands and tundra of Iceland.

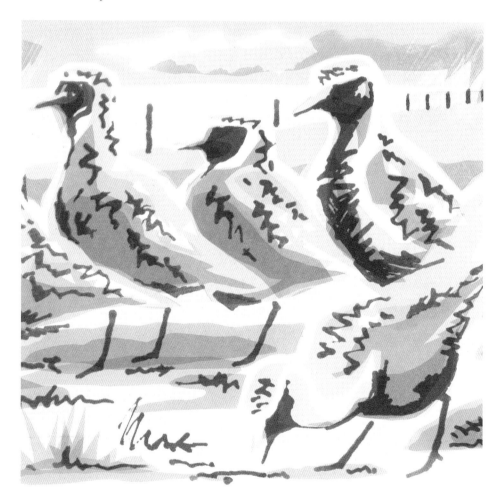

# Wheatears

Wheatears are always the first of the small birds to return after winter. At last there is warmth in the sun, and as I walk along the shore I find two male wheatears fluttering about the lichen-encrusted boulders. The rocks have absorbed the heat and the first insects have emerged, dancing in the rising air. The wheatears have come all the way from south of the equator, but they have timed their return perfectly.

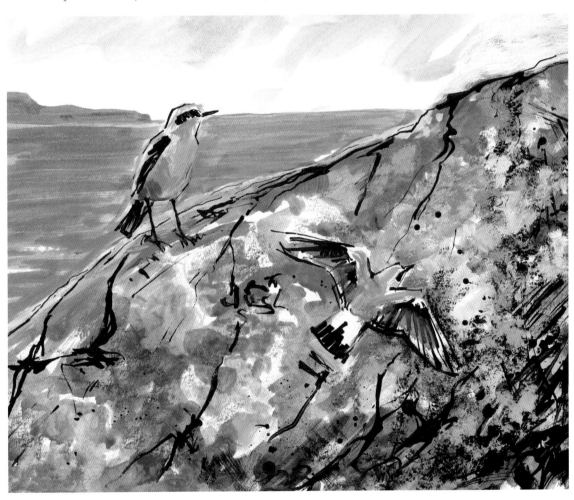

# Godwits

The spring migration is soon in full flow. Many birds follow the coast north, and stop in quiet places like Oronsay to rest and refuel. I look up from my drawing to see a group of large waders alight by the pools. They are black-tailed godwits, a bird I've hardly ever encountered. It is exciting to see such charismatic visitors. With their gawky legs and upturned bill they are comical and elegant at the same time.

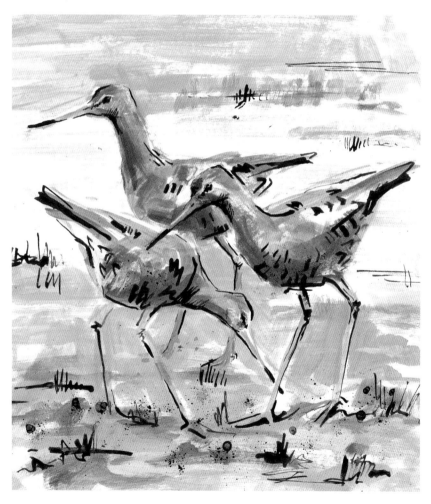

# Lapwings

'Mind your head,' shouts Mike as we lurch across the uneven machair fields in the Land Rover. It is dawn, and we are here to count breeding lapwings and redshanks.

We stop to watch a male lapwing digging a nest scrape. With chest lowered and tail raised, his legs scratch out a depression where the female may lay her eggs. He makes several of these scrapes using this stylised display, and the female will inspect them all before selecting a nest that meets with her approval.

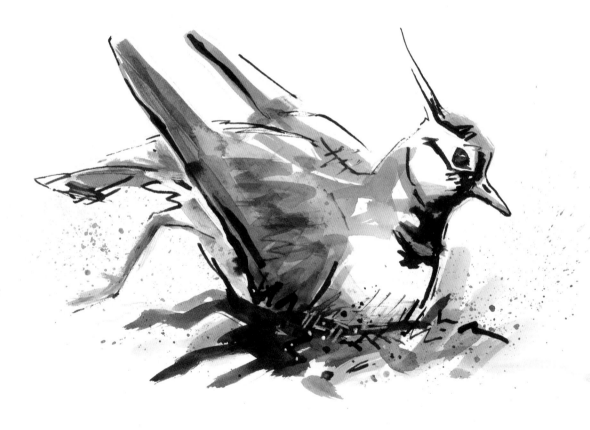

We park on high ground and look down across the marshy coastal fields. The sun has just risen and all the hummocks are rimmed with lime-bright green against the purple shadows. A male lapwing stands guard on one of these tussocks. His iridescent plumage glows with viridian, magenta and burnt orange, and his long black crest flutters in the breeze. He tilts his head and one large dark eye examines the sky. Then, with a reedy call, he takes flight. A hooded crow is over-flying the marsh. The crow is quickly surrounded by a squadron of lapwings, escorting him out of their territory. Finding themselves airborne together, the lapwings indulge in some aeronautical acrobatics, showing off to their neighbours with a noisy fly-past and filling the huge Hebridean sky with rollercoaster loop-the-loops.

The male returns to his hummock. It provides the perfect lookout point, and generations of lapwings have stood here to guard their territory. Their droppings have fertilised the grass in this one spot, causing it to grow more vigorously. Once I get my eye tuned to these hillocks, I can pick them out across the landscape. They are convenient perches above the boggy ground, and not just for lapwings. From here a wheatear can watch for insects, or a buzzard can search for small mammals. All the birds contribute to the nutrient supply and the mound rises several inches above the marsh. It becomes drier and ants move in, bringing more nutrients in their turn.

Asking around, I discovered that these hummocks have a name. They are known as tumps, a combination maybe of bump and tumulus (or even dump!). It's not surprising I didn't know the word, as farming machinery and fertilizers have improved most modern fields and removed these complex and elegant interactions of wildlife and landscape.

# Divers

It's dreich, as they say here, halfway between rain and mist. It's a good day for being inside. I use the time to hang an exhibition of my pictures on Colonsay in the old stone building that used to be the ferry waiting-room. The modern CalMac waiting-room and new car-ferry terminal across the road have vanished into the weather.

I am about to start work when a fluting call drifts hauntingly through the moisture-filled air. It seems to be coming from the sea. I walk out onto the new pier. Shadowy shapes are drifting on the water. As I walk further out above the waves, the shore disappears into the mist. The wind is humming in the iron railings and whistling gently through the massive bulk of the hydraulic ferry-ramp. I feel as if I'm on the bridge of a spaceship, looking down on a scene unchanged since prehistory. Up through the water rises a broad body, breaking the surface with hardly a ripple. A great northern diver.

It must be waiting here for the weather to improve. Soon it will leave for the tundra lakes of Iceland or Canada, where it will breed. It is already moulting into its summer plumage. Its dark streamlined back moves as part of the water, and is spangled with a pattern of white dots. Overlying this, a scattering of water droplets has settled on its water-repellant feathers. The chisel bill gives a fierce appearance. Running back from its breast in delicate rivulets, black striations follow the curves of its body. I try desperately to remember all this detail for a picture.

Further off, another diver surfaces. It is a more smudgy-white and calls quietly as if needing reassurance. It keeps a nervous distance from me, and is possibly a younger bird. Suddenly, as if slipping through from another dimension, a pair of razorbills pops up. They are tiny next to the diver. Their expressionless black heads peer from side to side and then, with a little growl, they vanish under the surface.

The adult diver ignores me. I might as well be a creature from another planet. It dips its head below the waves. Maybe it is watching the razorbills flying through the dark space below, or maybe it's looking for food. With one fluid movement the diver glides beneath the green surface. When it reappears it has a whole langoustine in its bill. The crustacean

is adjusted to a more convenient position and then swallowed whole. I really didn't expect that. What sort of stomach can deal with a live langoustine?

I realise that I'm getting cold, and a little peckish myself. I start back down the pier to my own life in the present day, pondering on my alien encounter. The mist closes behind me on the diver's world, a world parallel to mine, but at the same time a world so unknown and strange.

# Eiders Nest-prospecting

The eider ducks have progressed inland. Their heavy bodies and short legs are suited to landing on water rather than hard ground. To prospect for nest sites they must waddle all the way up from the shore. I use the Land Rover as a hide to make some sketches, and move very slowly. If I disturb them they will fly back down to the sea, and have to repeat their laborious trek up hill. The male escorts the female, who inspects the potential of clumps of bracken while he stands guard. Once she's laid the eggs, she'll only leave the nest morning and evening, to feed.

Eiders used to be a common sight in Oban among the tysties. On the mainland they are threatened by ground predators such as the introduced mink, but here there are only traditional predators to deal with. When the eggs hatch in a month's time, the chicks will have to run the gauntlet of gulls to reach the shore. My husband, Mark, remembers trying to film chicks leaving their nest on Oronsay. He stayed all day in a cramped hide until dusk at 11pm, and returned before dawn at 3am, to find that the female had led her chicks away under cover of darkness. Eiders may look comical, and might be losing out to predators in much of their range, but they are no fools.

# Seabirds Return

Most of Colonsay and Oronsay's seabirds have spent the winter fishing, out at sea. Guillemots are now returning from the English Channel, and razorbills from the Bay of Biscay. They are feeding offshore, but soon the cliffs will be ringing with their calls.

Shags.

# MAY
## *Through the Corryvreckan*

In summer the Wednesday ferry to Colonsay makes a voluntary detour through one of the most dangerous sea passages in the country. The huge boat turns into the narrow strait between the islands of Scarba and Jura, so that visitors can appreciate the Gulf of Corryvreckan, one of the world's largest whirlpools.

At flood tide, water from the Sound of Jura is forced through this channel into the Atlantic, surging over peaks and troughs in the seabed. At the autumn equinox, with wind against tide, there can be a standing wave six metres high, and the roar of the maelstrom can be heard from the mainland. Tradition tells that this turning point between autumn and winter is when the Cailleach, or Old Hag, uses the whirlpool as a washtub for her plaid shawl. The Gaelic name of this place, Coire Bhreacain, can translate as Cauldron of the Plaid. The Cailleach's shawl emerges clean and white, and becomes the snow that covers the hills.

On this sunny spring morning, the Hag must be asleep. From the high deck of the ferry the water looks smooth below. Only the gannets riding the updraughts around the boat lend an air of wildness. Years ago I kayaked through here with Mark. The weather was calm then too, but at water level the power of the tide was apparent. We had waited for slack water, but that only lasted a few minutes before the current started rushing in the opposite direction. We sneaked along the shoreline, paddling over smooth mushrooms of upwelling water. On another occasion we travelled through the Gulf in a powerful motorboat, when the tide spun us about like flotsam.

Today, razorbills fly fast and low over the flat sea. They are off to feed in the Great Race, which flows out of the Gulf. Here, the turbulent water brings nutrients and fish to the surface. This seafood banquet fuels the thousands of birds that are now preparing to lay eggs. They nest on steep sea cliffs, which Oronsay does not have, but Colonsay does.

# Seabirds

At this time of year the tall cliffs on the west coast of Colonsay are home to fifty thousand seabirds. Everything about this colony is overwhelming – the acrid smell of droppings, the cacophony of calls echoing off the cliff wall, the flapping and squabbling as birds return to their ledges, greeting partners and repelling rivals. Waves surge against the cliff below and birds wheel through the air above. I have to hold on tightly so as not to lose my balance.

The cliffs are a huge tenement, full of bickering neighbours. As I watch, I start to pick out the different characters. Kittiwakes occupy the upper floors, and with their large dark eyes and elegant manners, they are the Audrey Hepburns of the block. Lower down are single nests of shags, and off to the side are the happily married pairs of fulmar. They pair for life and can live for fifty years. They peer down from their balconies onto the bustling pavement where guillemots are jostling and jabbing on the narrow ledges. At basement level are many razorbills with their inscrutable faces, black jackets and motorbike growl. Their powerful bills make them look intimidating, but they groom each other delicately. It has been found that birds showing more of this mutual grooming have higher breeding success.

Last year I met RSPB scientist Ellie Owen here, and she helped me understand the order behind all the apparent chaos on the cliffs. She was working on the 'Future of the Atlantic Marine Environment' (FAME) project, and with assistant Tessa Cole was attaching GPS trackers to some of the birds, to find out where they were fishing.

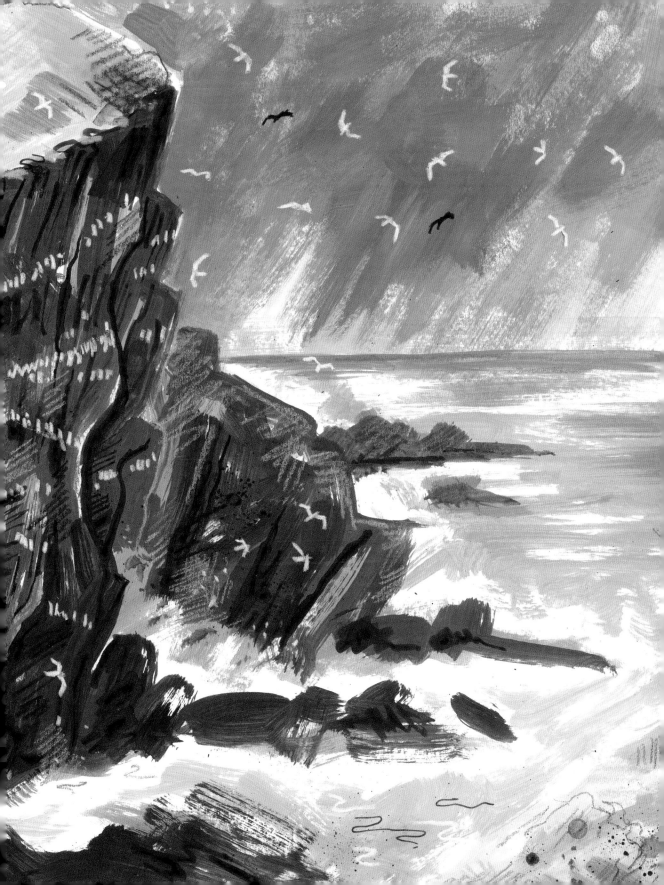

'When we look out at that featureless expanse of sea,' said Ellie, 'it's hard to imagine how the birds know where to find food. But now that GPS locaters have become widely available and cheap to use, we are able to provide answers to questions that scientists been waiting years to answer.'

It's relatively easy to protect a seabird cliff, but it is pointless if the birds' feeding grounds are not also protected. Raising young takes a lot of energy. Industrial fishing means that there are fewer fish left in the sea, and the GPS technology reveals that some birds are flying 3-400 kilometres per fishing trip. They must eat enough to sustain themselves and carry food all the way back to their chick. Ellie showed me the flight paths on her computer. She can identify a feeding area where direct, straight-line flight becomes wiggly 'silly string'. Undersea ridges and cliffs create upwellings, and here the flight paths twist and turn as the birds feed. 'Because none of us can see what is happening under the water, it is often a case of "out of sight, out of mind",' she continues. 'These special seabird feeding areas are also often where fishing boats congregate, and where offshore wind farms may be built. Without this crucial information, we wouldn't know if we were at risk of destroying vital feeding grounds.'

Different species have their preferred feeding locations. Each species has become expert in a particular type of fishing, so that they don't compete against each other. For example, terns pick the tiniest sand eels from near the surface of the sea. Puffins and razorbills have hinged beaks that open in parallel, allowing them to catch several medium-sized sand eels without losing fish already in the bill. In contrast, guillemots' beaks open like scissors, allowing them to carry just one larger fish. To hunt deep below the waves, they use their small wings as flippers. Gannets have larger wings and can't 'fly' in water. In order to reach bigger fish, they must plummet from high above the sea, folding back their wings as they hit the surface.

# Shags

Shags don't have waterproofing on their wings. This makes swimming under water easier, but they must hang their wings out to dry after diving. With their guttural call, scaly-looking feathers and long snaking necks, shags look like quite primitive birds.

# Kittiwakes

With their broad 'dipped in ink' wings, the kittiwakes dance in the up-draughts of the cliff face. They are like snowflakes drifting across the black rock until, with a gentle flap, they alight on their grassy nest. Their loud 'kittiwake' call bounces off the cliff, cutting through the booming of the breakers in sea-caverns below.

A rain shower passes through and all the kittiwakes fly up to the cliff edge to tug at the muddy grass with much calling and fluttering. They pile the grass on their nests, cementing it with droppings. Over the years these nests grow into neat pillars, and the droppings provide a record of what the birds have been eating. Scientists can drill cores through the nests to monitor changes in food availability.

Because they can't dive as deep as guillemots, or fly as far as fulmars, kittiwakes have been the hardest hit by recent fish shortages.

# Auks

Over half the occupants of the colony are guillemots. They and their cousins, the razorbills, are members of the auk family. Their wings are just big enough for flight in air and just small enough for flight under water. They can dive to one hundred metres below the surface to fish. In air they power towards the cliff, wings whirring, and at the last minute drop onto their ledge. Another cousin, the great auk, dispensed with flight altogether, which allowed it to become much heavier. Unfortunately both its meatiness and its flightlessness made it a desirable food for sailors, and by the 1840s it had become extinct.

The razorbills on Colonsay are doing well, as they fish in the turbulent waters of the Corryvreckan. Birds tracked by FAME from Fair Isle had to fly over 300 kilometres for food, compared to just 34 kilometres here. This has meant a higher breeding success for the local birds.

Razorbills.

Opposite:
Guillemots.

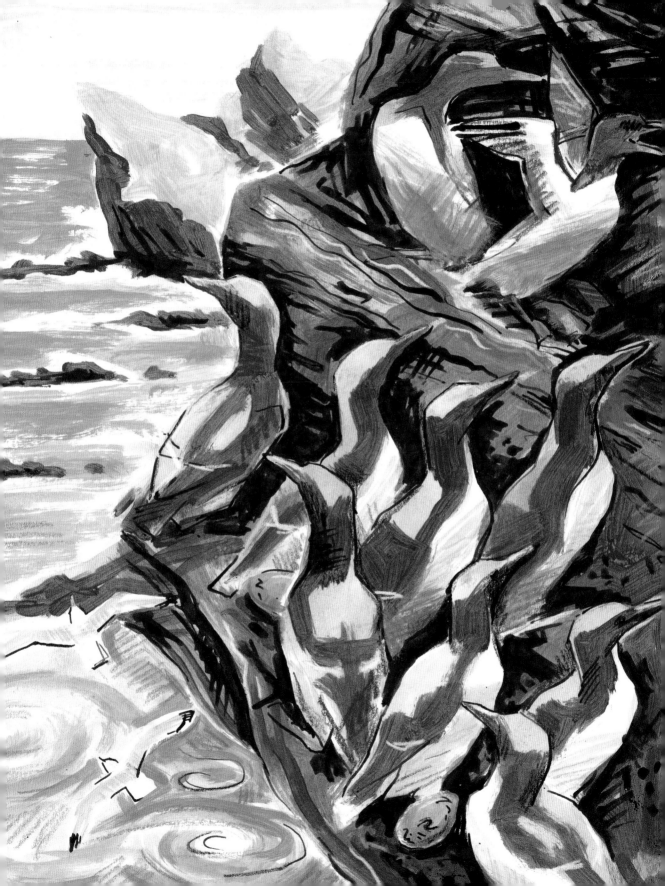

# Fulmars

As I sit painting on the cliffs, the fulmars whizz past me, only feet away. They ride the wind with their short, stiff wings, and use their feet as brakes. They are relatives of albatrosses, and use their tube noses in the same way, to find food. They can smell dimethyl sulphide, which is given off by plant plankton when it is eaten by animal plankton. Fulmars can eat the animal plankton, or the fish which gather to eat this krill. Unfortunately, plastics floating in the sea also give off the same smell. Fulmars are scavengers, pecking at any small floating material. Their stomachs digest any protein, and leave fish oil to be carried back to the nest. This is a very efficient way of transporting concentrated energy to the chick, unless, of course, their stomachs are full of plastic.

The FAME project tagged a fulmar from Orkney, which flew to Norway and back to catch fish for its chick, a trip of 470 kilometres. When food is in short supply, the bird's energy profit and loss account must be finely balanced. A stomach full of plastic tips the scales in the wrong direction.

The fulmar nesting ledges have been in use for years, and the birds' droppings have fertilised them, creating little gardens of greenery. Often the couples sit there companionably. The surrounding plants match the blue-green of the birds' bills and feet, and I am inspired to start sketching. It is thought that birds use colour to advertise their health to their partners. The colour is energetically expensive to produce, and the healthiest birds have the brightest legs and feet. In this way the partners can reassure each other that they are fit enough to commit to the hard work of raising a chick.

Every so often a bird shakes its head with a salty sneeze. Fresh water is not available at sea, and the birds get rid of excess salt through their noses. Another antisocial trick protects them against predators. They can regurgitate the oil from their stomachs and spit it at intruders. I've had this happen to me, and the smell is enough to make me stay well clear in future. This horrible habit is the origin of their name, which comes from Old Norse, *full mar*, meaning foul gull.

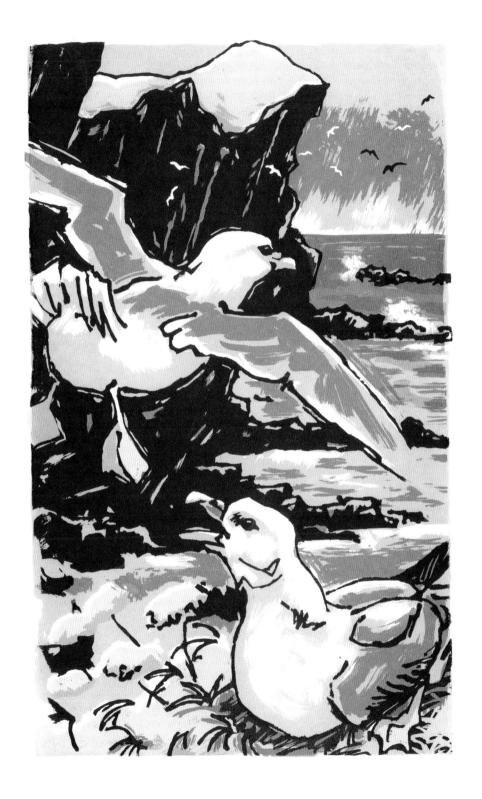

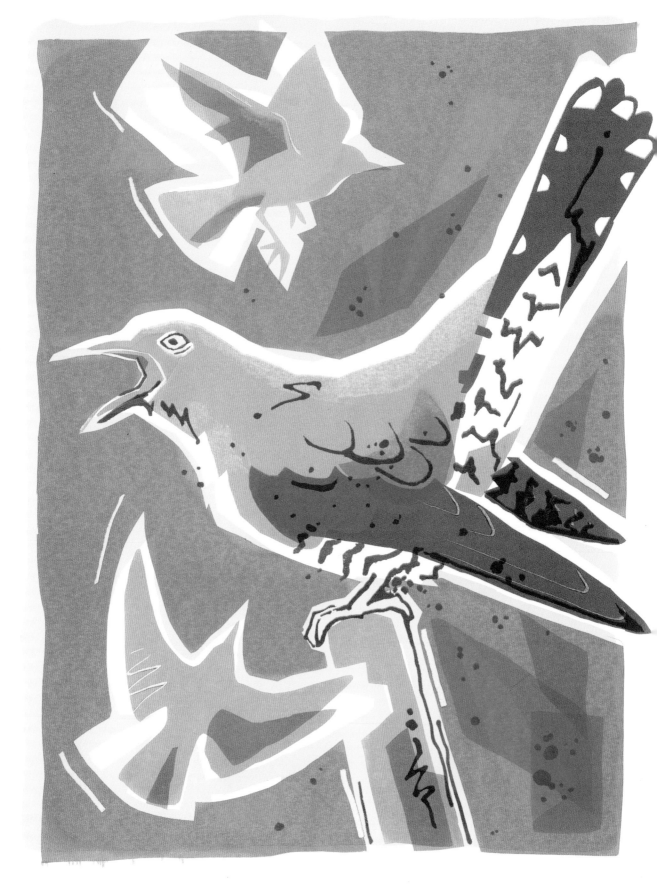

# Birdsong

On my way back from the sea cliffs I have to stop the car and just listen. The centre of Colonsay, only a mile from the windswept coast, is a rich mixture of woodland, meadows and rough grazing land. A mid-May evening is a time of perfection here. Hanging out of the car window, I hear corncrakes rasping in the rushy field edges, a blackbird carolling in the oak tree above, willow warblers, whitethroats, a song thrush with its repetitive phrases, the scratchy song of a sedge warbler, and the distant wooden-fluting of a cuckoo. In the meadow a grasshopper warbler reels out its namesake's whirr without pausing to draw breath. The fresh, new leaves flutter and glow, as they are backlit by the evening sun. Above the trees, swallows swoop, and below, there is the azure shimmer of bluebells. A background hum reveals the presence of countless bees, pollinating the willow catkins and the air is full of the pale scent of wild garlic. It is as if the turning of the earth has brought all these participants together at this moment, to create magic.

Which of course is what has happened. Corncrakes from the Congo, swallows from Senegal, blackcaps, garden warblers and redstarts from sub-Saharan Africa, have all returned here to breed in the long Scottish summer days. The sun's heat coaxes forth fresh foliage, caterpillars hatch out to feast on the leaves, and so a banquet is provided for the birds. They sing to find a mate and lay claim to a patch of bramble or treetop. Their songs have developed over time to be heard within the chorus, fine-tuned to a pitch and volume that will not conflict with others. How many thousands of years of evolution has it taken to arrive at this moment? It is intoxicating in its simplicity and complexity.

Opposite:
Cuckoo and meadow pipits.

# Colonsay Corncrakes

As part of the Colonsay Spring Festival I led a drawing workshop, sketching chickens in someone's backyard.

'You should have been here five minutes ago,' laughed the owner. 'We've just had a corncrake walk into our kitchen through the cat flap. There's a lot of fuss made about them around here, but it really was quite pretty.'

It's a strange life that corncrakes lead. No one knew where they spent the winter until recently, when scientists on a neighbouring island attached tiny Geolocators to their legs. It was revealed that these birds winter south of the equator in the Congo, flying a round trip of over fifteen thousand miles.

For a bird with such wide horizons, corncrakes seem to live in their own small world. Mark remembers waiting patiently to film them, when one bird crept under the canvas at the front of his hide, walked between his legs and left through the back.

# Waiting to See a Corncrake

I cross from Colonsay to Oronsay at night under a half moon, and the still air is full of corncrakes craking. The calls are insistent, rhythmic and loud, all slightly out of sync with each other, so the rhythm of one gradually overtakes its neighbour. When another deeper, more determined voice starts up even closer, merging into the head-filling buzzing, I can't help laughing at the madness of it all. Corncrakes seem to call near walls and buildings so the vibrating bass is amplified and bounces off the stone. No wonder the people who farmed here one hundred years ago considered them pests. Flora spoke of her mother chasing after them in her nightgown when she couldn't get to sleep.

I hope to draw the corncrakes, and I settle down in the early morning sun at the field edge. The early cover of nettles and cow parsley is now well grown and other species are benefiting from it too. A whitethroat is singing energetically and hunting for insects amongst the nettles. Sparrows are peeling strips from last year's dried plant stems to thread into their nests. Swallows are collecting mud from the tractor ruts in the road. Some bring dry grass in their beaks and use the mud as cement.

I think the crakes must be sleeping after their busy, buzzy night. There's no sound from them. I go in for coffee and Mike tells me of one night when he saw strange clouds shimmering over the corncrake fields. Closer inspection revealed thousands of ermine moths dancing in the moonlight. 'It was just magical,' he says, 'and just think how many insects those fields are growing. All good corncrake food.'

Val tells me the best time to see corncrakes is after rain or dew, when they come out of the damp undergrowth to dry off in the sun. It's a day of sunshine and showers, so I persist in my quest. I settle on the verge again and start to paint nettles and plantain. After half an hour there is a flash of orange, and a bird like a small chicken emerges from the undergrowth. It crouches, low and circumspect, crosses the track on long strides, and disappears into the vegetation again.

# Arctic Tern Colony

From Oronsay we can see a shimmer of terns above the beach on Ghaiodeamal. Mike wants to check if they are breeding, now that the rats have been cleared from the island.

As we set out in the boat, we can see the Arctic terns fishing. Their bodies are so light that they bounce on the air with every lilting wing beat. One bird pirouettes on the breeze and then plunges into the water. It emerges, shedding water from its dry feathers, and with a silver sandeel in its beak.

We don't stay long on the island as we don't want to disturb the colony. A quick look is enough to see that the birds are nesting among the sea campion. If chicks fledge this year they will be the first in years.

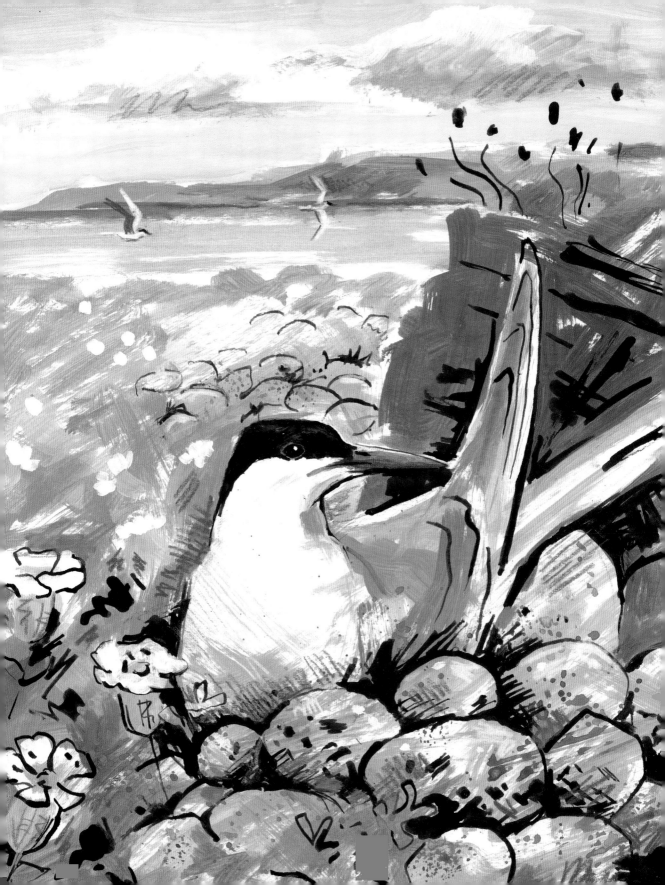

# Chough Chicks

When Oronsay's chough chicks are big enough, a visiting scientist comes to measure and mark them. He puts a tall ladder up to the nest in a cave, and the chicks are brought down carefully. Last year (as described earlier) the Oronsay male chough took a new mate after the death of his partner. None of the new couple's chicks fledged as they were all found to be blind. Because the population here is so small, genetic problems like this are likely to arise, making the birds even more vulnerable.

This year it appears that two of the three chicks are sighted, which is a relief. They are marked with colour rings that can be seen from a distance. In this way individuals can be recognised and valuable information learned about their behaviour.

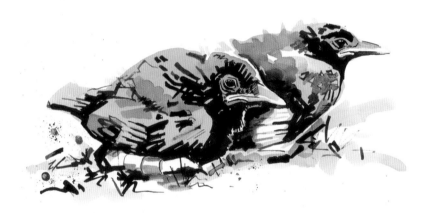

# Starlings

The starlings have an insatiable urge to build nests right now, and a warm engine sheltered under a tractor bonnet seems to offer the dream location. Even though the vehicles are cleared of straw every morning, by the end of the one-hour lunch break another nest will have appeared. 'They must be crossing their legs is all I can say,' laughs Mike. I climb into the tractor cab with my sketchpad and watch the birds lining up along the fence, beaks full of straw from the barn. In their glossy breeding plumage they are outrageously colourful.

When it's time for me to catch the ferry, Izzy offers to give me a lift across the Strand. We are chatting away, until I catch the faint smell of smoke. 'Oh no!' shouts Izzy as we screech to a halt. 'I forgot to check for starling nests!' She jumps out to rummage under the bonnet, chucking handfuls of straw out behind her. Sometimes it's hard to know who has the upper hand on this island, the humans or the wildlife.

# Conclusion

Landscapes change. Farming techniques change. People change. Eighty years ago Oronsay was farmed by Gaelic speakers who crofted in harmony with the land, using horses and manual labour. Six thousand years ago the climate was much warmer, and people hunted cranes and great auks here. So why put all this hard work into keeping things the way they are now? If corncrakes and choughs can't fit in with our modern farming methods, shouldn't we just let them go? There are still corncrakes and choughs left in other parts of Europe. Wouldn't it be easier to let other countries protect them?

I put these questions to Mike, who was kind enough to reply to them patiently. The first reason for protecting these birds is that by protecting their habitat we protect the whole interacting system of wildlife around them in a cascade of consequences. To grow corncrakes we grow cow parsley, which grows ermine moths, which grow bats and swallows, which grow sparrowhawks.

There are countries in Eastern Europe that hold bigger populations of corncrakes, but as agriculture is modernising there, their numbers are falling. Scotland is the only country where numbers are increasing.

Secondly, as global conditions change, wildlife needs to be able to adapt. If species only exist in the centre of their range, they have no room for manoeuvre. Choughs are on the edge here, the nearest stable population being hundreds of miles away. If lost from Scotland, their range would contract dramatically. Because choughs rely on local knowledge handed down from parent to offspring, they find it very hard to re-establish in an area, once evicted.

Lastly, there is an emotional reason. Once you know that the corncrake can find its way every year back from the Congo to the same nettle patch in Scotland, flying at night, using the stars and the earth's magnetic field for guidance, how can you not fight for its survival? Once you see the swooping flight of choughs playing in the sea breeze, hear the magical call of great northern divers, or discover cuttlefish like pink winged elephants, how can you not move over, to leave a little space for them?